IMAGES
of America

INMAN PARK

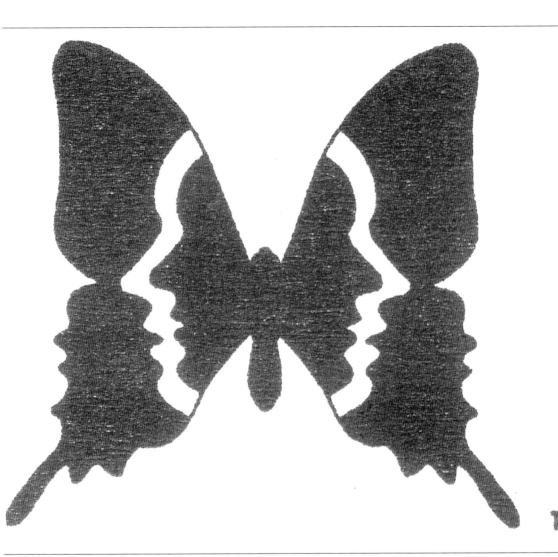

As the emblem of Inman Park, the butterfly is symbolic of the neighborhood's enduring legacy. Within the butterfly are the two heads of Janus, the mythological god of time; as stated in the 2003 Inman Park Neighborhood Association Membership Directory, "one looks to the past and the beauty of Inman Park's youthful years, the other looks ahead to the second flowering of that beauty." The 1970 design of this yellow-and-black symbol, which is displayed throughout the neighborhood on banners and flags, is credited to former resident Ken Thompson. (Inman Park Neighborhood Association Archives.)

ON THE COVER: In this picture known by local historians as the "Tea Party" photograph, this c. 1900 party was held at the Beath-Dickey-Griggs house at 866 Euclid Avenue when the Dickeys made this Queen Anne Victorian their home. The house was originally built in 1890 for John M. Beath, president of Atlanta Ice and Coal, as a wedding present for his wife. (Robert Griggs.)

IMAGES
of America

INMAN PARK

Christine V. Marr and Sharon Foster Jones

ARCADIA
PUBLISHING

Published by Arcadia Publishing
Charleston SC, Chicago IL, Portsmouth NH, San Francisco CA

Printed in the United States of America

Library of Congress Catalog Card Number: 2008927462

For all general information contact Arcadia Publishing at:
Telephone 843-853-2070
Fax 843-853-0044
E-mail sales@arcadiapublishing.com
For customer service and orders:
Toll-Free 1-888-313-2665

Visit us on the Internet at www.arcadiapublishing.com

This book is dedicated to the Atlanta Preservation Center.

CONTENTS

ACKNOWLEDGMENTS

We acknowledge with gratitude the many neighbors and former Inman Park residents who have contributed to this collection. It has been a pleasure to connect with Inman Park residents, both old and new, on such a personal level and to hear the many stories that accompanied these images. Among the many who contributed their wise counsel are Pat Westrick, Diane Floyd, JoAnne Bowers Chew, Jennifer Miller, Judy Hotchkiss, and Robert Griggs.

We appreciate the assistance of the Inman Park Neighborhood Association (IPNA), the Inman Park United Methodist Church, and the Episcopal Church of the Epiphany for granting access to and use of their archival materials. Several images were acquired from collections at the Georgia State Archives, Georgia State University, and the Atlanta History Center, and we acknowledge and appreciate their service to Atlanta and their safeguarding the city's rich heritage. We appreciate the fact-checking and friendly expertise of Rebecca M. Roberts, Midge Yearley, Regina Brewer, Jan Keith, and Aline Henderson, all of whom are staff or volunteers at the Atlanta Preservation Center. A special thank you goes to Arcadia Publishing, and specifically to Katie Stephens, acquisitions editor, for her guidance and encouragement throughout the publication process.

Lastly, we thank the Marr and Jones men—all seven of them—for existing on pizza while we prepared this book.

INTRODUCTION

Let no one despond as to the future of our city! . . . What Atlanta now first needs is energetic, good government. This, combined with devoted loyalty and enterprise on the part of her citizens, and she will soon rise from her ashes. . . . [Her] citizens must put their own shoulders to the wheel, and push hard. . . . Efforts like these will soon restore her to her former greatness.

—*Atlanta Daily Intelligencer*, December 1864

Inman Park has reflected the determined, progressive Atlanta spirit for more than 100 years. The Inman Park Historic District of today was vast farmland in the antebellum era and almost completely owned by three siblings: Augustus Franklin Hurt, George Troup Hurt, and Mary Elizabeth Hurt Jones. Augustus Hurt owned a working plantation in the northern portion of today's Inman Park, and his home was located squarely on the hill that is now topped by the Jimmy Carter Presidential Library and Museum. His brother and sister both built houses in the southern part of today's Inman Park by the railroad tracks. The home of Mary Elizabeth and her husband, James V. Jones, was a simple farmhouse, built in the early 1850s. Troup Hurt was in the process of building a brick mansion in 1864 when its construction and the tranquility of rural life was interrupted by the Civil War.

In July 1864, Atlanta heard the musket shots of Federal troops as Gen. William T. Sherman pressed down upon the city from the north. General Hood and his Confederate troops valiantly fought to defend Atlanta, the nerve center of the Confederacy with its railroad connections and trade network. The troops met in the groves of what would become Inman Park on July 22, 1864. These decisive moments in Atlanta's history are depicted with lifelike intensity at the Atlanta Cyclorama, including images of the homes of Troup and Augustus Hurt, with Union and Confederate soldiers struggling for control of the territory. The Union soldiers vowed to have dinner inside Atlanta's city limits that night, and they failed at a cost of more than 9,000 Union and Confederate soldiers' lives. The Union soldiers did not dine in Atlanta on that day, but they laid siege upon Atlanta for weeks until she surrendered. Atlanta was burned as the Federal troops left town in November, and the surrounding lands were ruined. The area of today's Inman Park was destroyed from the Battle of Atlanta. Hundreds of dead horses lay rotting in the fields. Birds ceased to sing. The land was treeless and raw. Lonely chimneys stood as monuments to the farmhouses and plantation houses that had existed before the war.

Two decades after the Civil War, Joel Hurt, a civil engineer and renaissance thinker, purchased the land of cousin Mary Elizabeth Hurt Jones with the idea of building a residential park. Previously Atlantans lived in an urban grid-like system of streets or on farms. Hurt desired to offer the upper-class citizens of Atlanta a refined place to live in a park-like setting with the latest in urban transport: the electric streetcar. He and other wealthy investors such as the neighborhood's namesake, Samuel M. Inman, formed the East Atlanta Land Company to carry out Hurt's dream of Inman Park—a thriving emblem of the progressive, post-Reconstruction New South.

Many of Atlanta's most influential families came to live in Inman Park between 1890 and 1910. This gracious Southern neighborhood blossomed into a pastoral utopia and became home to Atlanta's most prominent boosters, including Coca-Cola magnates Asa Griggs Candler and Ernest Woodruff. The names of many original Inman Park residents are still well known, as their distinction and service to Atlanta have left their esteemed legacy.

After 1910, the social tone of Inman Park transformed. The combination of a lapse in land use restrictions in 1910, the advent of the motorcar, the early development of Druid Hills designed by Hurt and Frederick Law Olmsted, and the increasingly subdivided Inman Park properties led to a swift exodus of the founding families. A new era harkened as Inman Park echoed the leitmotif of Atlanta's rebirth. The surge in the construction of smaller homes in a variety of new century styles—bungalow, American Foursquare, and folk Victorian—set the stage for a new middle-class life in Inman Park. Commercial properties sprang up, as well as apartment buildings, and the texture of Inman Park achieved a more universal spirit. This prosperity gave way to the 1950s housing crisis and resultant suburban sprawl. Neglect of the Victorian homes and gardens marked a dark period in Inman Park's history.

In the late 1960s and early 1970s, a few pioneering individuals who appreciated the beauty of the grand homes lining Inman Park's avenues set out to reclaim the neighborhood. A slow recovery was made with little help from the City of Atlanta or the State of Georgia. In the 1970s and 1980s, residents organized to protect against the state's attempt to pave a major expressway through the neighborhood. While many homes were demolished in preparation for the highway, the neighborhood association succeeded in defending the historic and practical aspects of Inman Park. A new type of determined Atlantan walked the winding paths of Inman Park, and through the progressive efforts of those Inman Park residents—which included the harnessing of brilliant legal minds, capturing the interest of elected officials, and even chaining themselves to trees—Joel Hurt's vision of useful citizens living in a park-like setting was finally realized.

Today Inman Park is a splendid example of historic preservation, authentic in its architectural integrity and cohesive as a neighborhood of caring citizens. Most of the homes have been renovated to recreate the authentic Victorian feel of the neighborhood, and the spaces once cleared for the expressway have been landscaped into rolling hills of paths and parks. The Inman Park Neighborhood Association remains strong and guards its "Smalltown Downtown" with the members' talents and enthusiasm. As an example of the unique bonds that exist between Inman Park residents, each year the residents organize Atlanta's largest and most eccentric neighborhood festival. Attended by thousands, the Inman Park Festival, held the last weekend in April for several decades, includes a dazzling parade, artistic presentations, and the beloved tour of homes. Inman Park has risen from its ashes and proudly represents the tradition of ingenuity, progressiveness, and diligence sustained by Atlantans today.

One

THE IDEAL SUBURB

After the Civil War, the rebuilding of Atlanta was nothing short of miraculous as the city's citizens heeded the call to action. Determined to triumph over the humiliations of the war, Atlanta's leaders set about re-creating a city to rival any of the great urban centers of the Northeast. Cotton and other rail-supported industries thrived, and so did the families who owned these lucrative and growing businesses.

By the late 1880s, Atlanta's downtown commercial district was expanding, and the city's social elite who lived in the grand homes along Peachtree Street sought new residential establishments unfettered by the bustle of downtown commerce. In 1886, Joel Hurt, a civil engineer and businessman, had the idea to create Atlanta's first planned residential suburb. Every Northeastern city had such a street or suburb with ease of access to the commercial center while offering the aesthetics of pastoral life, and Atlanta deserved to have such a suburb. Hurt established the East Atlanta Land Company to oversee the development of this ideal residential suburb, and he formed the Atlanta and Edgewood Street Railway Company to create Atlanta's first electric streetcar system along the new Edgewood Avenue. The war-torn land on the east side of Atlanta was a perfect host to Hurt's dreams.

Once the land was prepared, the first auction of land lots was held in May 1889. Four deed restrictions, effective through January 1, 1910, applied to all who purchased lots in Inman Park. First, land was for residential use only. Second, any residence was to be worth $3,000 or more—a great deal in that day. Third, each residence was to be set back 30 feet from the front street and 20 feet from any side street. Finally, terms were specified as one-fourth cash with the balance in one, two, and three years at eight percent interest. The auction was a great success; however, the expiration of these land-use requirements would prove pivotal in Inman Park's story.

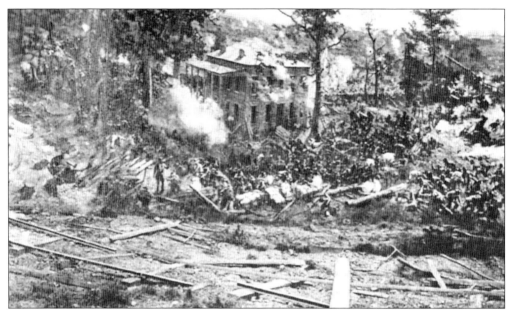

The Atlanta Cyclorama depicts the Troup Hurt house at the center of the Battle of Atlanta on July 22, 1864. Completed in 1887, this panoramic painting is 42 feet in height and 358 feet in circumference and shows the famous battle from a vantage point on the southern edge of Inman Park. This image of the painting was taken in 1919. (Sharon and Craig Jones.)

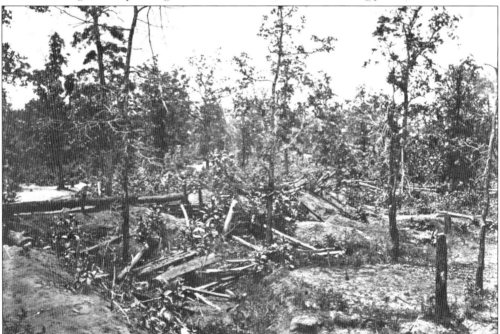

The ravaged land was all that remained east of Atlanta, as photographed by George N. Barnard on July 22, 1864. Augustus Hurt's plantation house, built around 1858, was used as General Sherman's headquarters that day. His stately home, however, was not invulnerable to the destruction. It was destroyed by Union troops for use as firewood and to build temporary housing for their soldiers. (Sharon and Craig Jones.)

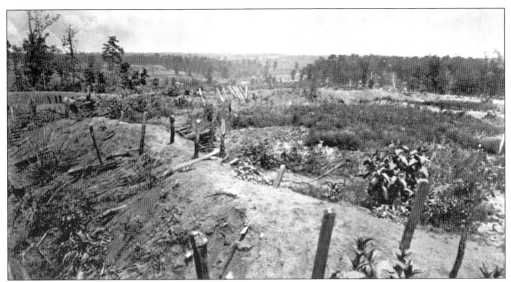

George N. Barnard photographed the ruined condition of the land in the vicinity of Inman Park on the day of the Battle of Atlanta, July 22, 1864. The treeless countryside was crisscrossed with trenches, forts, and batteries, giving the land east of Atlanta a desolate appearance. (Sharon and Craig Jones.)

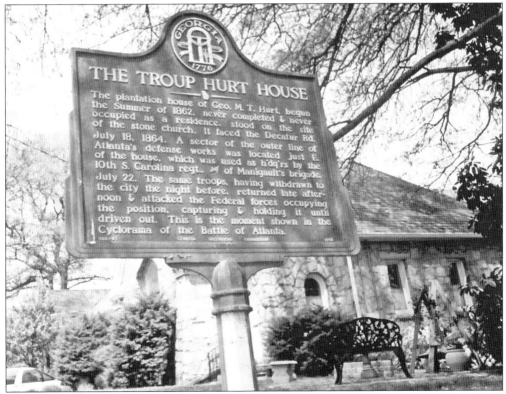

Historic markers such as this one at the Troup Hurt House have been placed throughout Inman Park. The East Atlanta Primitive Baptist Church was subsequently built on the site in 1907 but was closed in 1988. The church is now a single-family residence. (Sharon and Craig Jones.)

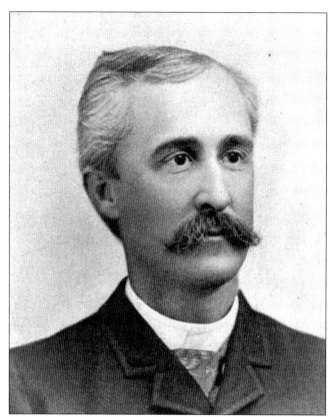

Joel Hurt, developer of Inman Park, was truly a renaissance man. Trained as a civil engineer, Hurt parlayed his enterprising genius into many Atlanta landmarks including the Trust Company of Georgia; Atlanta's first skyscraper, the old Equitable Building; the Hurt Building; and the Druid Hills residential neighborhood. Hurt's ever inquisitive mind is even credited with the discovery of canine hookworms. (Sharon and Craig Jones.)

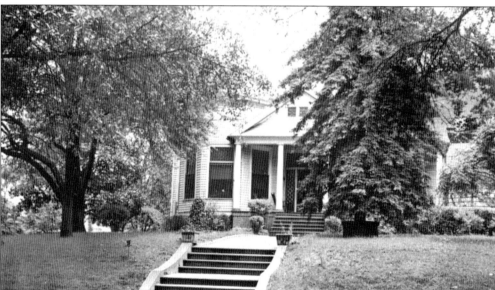

The Hurt Cottage, located at 117 Elizabeth Street, was the original farmhouse owned by Joel Hurt's cousin, Mary Elizabeth Hurt Jones, after whom Elizabeth Street was named. In 1887, Joel Hurt moved it from its original location on the Georgia Railroad to Elizabeth Street, adding Victorian features. Hurt lived in the house until 1904, when he built a larger house on the same street. (IPNA Archives.)

Samuel Martin Inman (1843–1915) owned one of the largest cotton brokerage houses in the world and was labeled by Henry Grady as the "first citizen of Atlanta." Inman was a significant investor in Joel Hurt's development company, the East Atlanta Land Company, and Inman Park was named in his honor. (Sharon and Craig Jones.)

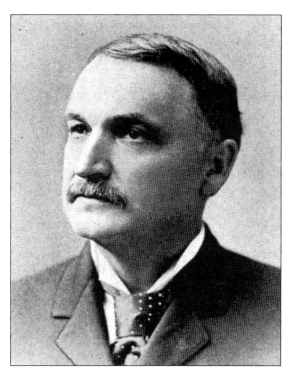

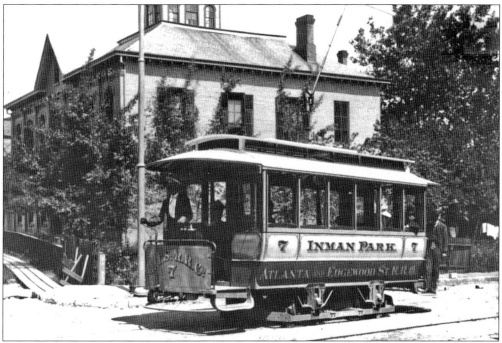

Streetcar No. 7 travels westbound on Edgewood Avenue at Equitable Place around 1890. Joel Hurt spearheaded the creation of Edgewood Avenue, which was done by connecting Foster Street in eastern Atlanta to downtown's Line Street. The first electric streetcar ran down Edgewood Avenue with much fanfare on August 22, 1889, with Henry Grady and Joel Hurt onboard. (Sharon and Craig Jones.)

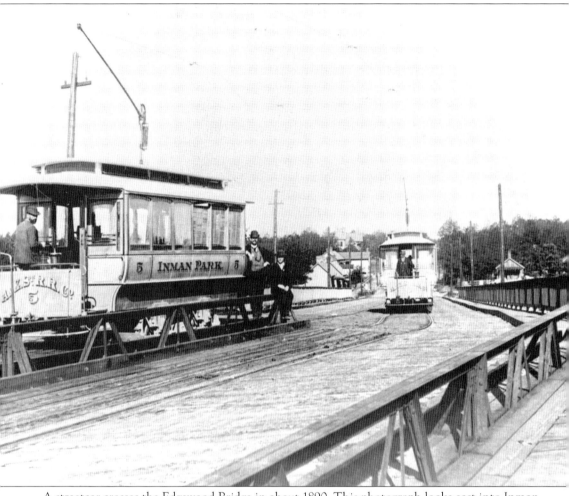

A streetcar crosses the Edgewood Bridge in about 1890. This photograph looks east into Inman Park, where the imposing Thomas W. Latham house at 804 Edgewood Avenue is visible in the distance. The smaller houses on the right were located on Gunby Street, which no longer exists. No expense was spared on the streetcars, built by Lewis and Fowler Manufacturing Company. According to the *Atlanta Journal* on February 22, 1890, "The cars cost ten times as much as ordinary streetcars. They are finished in finest style, with plate glass windows. It may interest the public to know what an electric motor car costs. Here are the figures. They cost $4,000 apiece!" The interior was of the highest quality as well, painted a beautiful yellow with orange shadings and polished brass hardware throughout. The round-trip travel time from Pryor Street downtown was 40 minutes. (IPNA Archives.)

According to the Atlanta Constitution on August 23, 1889, "Everybody had something to say about the motor, and those nearest indulged their sense of touch to their full gratification. . . . Many of the spectators had never seen an electric motor before, and not even the small cyclone that came up just before the start was made, could drive them away." (Sharon and Craig Jones.)

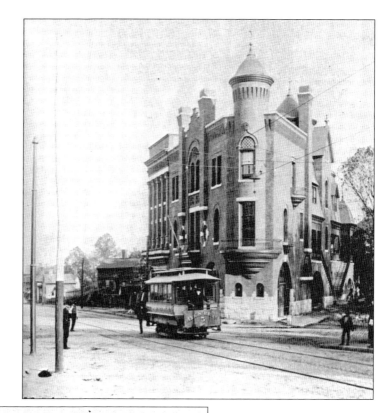

BUILDING.

OPENING OF EDGEWOOD AVENUE

That is What the East Atlanta Land Company is Doing.

Street Railroad Cars Run by Electricity—Beautiful Houses and Large Business Blocks.

This article announced the Edgewood Avenue project in the *Atlanta Constitution* on December 15, 1888. To provide a proper road for the new railway tracks, the Atlanta and Edgewood Street Railway Company spent $125,000 and demolished 94 buildings. The steel rails were heavier than those used by the Georgia Railroad and were laid on stone piers. Hurt likened the new Edgewood Avenue to Drexel Avenue in Chicago and Euclid Avenue in Cleveland. (Christine V. Marr.)

As a streetcar travels easterly on Edgewood Avenue, the newly finished Trolley Barn looms in the background around the year 1890. The Trolley Barn served as offices for the Atlanta and Edgewood Street Railway Company and was the repair depot for the electric cars. (Special Collections and Archives, Georgia State University Library.)

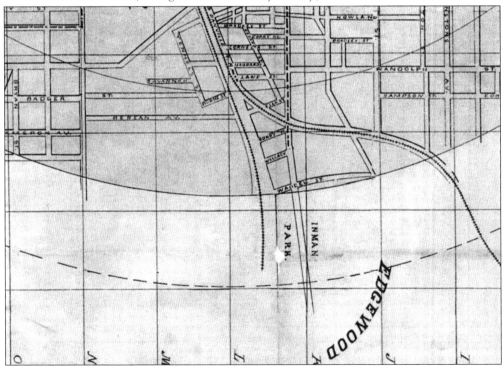

In 1889, this map was drawn by E. H. Hyde of Budden and Son Lithographers in Atlanta. The newly formed Edgewood Avenue ran from between the words "Inman Park" into downtown. On Edgewood Avenue, the street railway's construction progress is indicated by the long dashes, showing the trolley line was on its way into Inman Park. (Sharon and Craig Jones.)

FOR SALE!

Ten Choice Residence Lots

IN

INMAN PARK.

The East Atlanta Land Company

Having completed its work of two years, in laying out, grading, and otherwise improving this beautiful Residence Park, will offer on

The 9th of May, at 3:30 O'Clock P. M.,

On the premises, TEN CHOICE RESIDENCE LOTS. This property is by nature the finest in Georgia, and under the skill of Engineers and Landscape Gardeners, has been brought to a state of

Perfection as a Residence Park

In order to furnish an opportunity to the many enquirers to visit and examine it, the above sales will be made. These lots will be sold under restrictions allowing use

For Residence Purposes Only!

And the residences not to cost less than $3,000 each. Terms, one-fourth cash, balance in one, two and three years at 8 per cent. interest.
For information apply to P. H. HARRALSON,
Nos. 2 and 4 South Pryor Street, Atlanta, Ga.

"Perfection as a Residence Park," exclaimed this advertisement, taken from the *Atlanta Journal* on May 4, 1889. Joel Hurt's East Atlanta Land Company was formed with the intent to create a living space that had never been attempted in Atlanta: fine homes in a park-like setting along curvilinear streets. The first 10 land lots were auctioned on May 9, 1889, with four deed requirements expiring on January 1, 1910. First, land was for residential use only. Second, any residence was to be worth at least $3,000. Third, each residence was to be set back 30 feet from the front street and 20 feet from any side street. Fourth, terms were specified as one-fourth cash with the balance in one, two, and three years at eight percent interest. Subsequent auctions were held in February 1890, two in April 1891, and a particularly successful fifth auction in April 1896. According to the *Atlanta Constitution*, W. O. Beckenbaugh, "the well-known real estate auctioneer of Baltimore, known far and wide as the man who sold the world's fair buildings at Chicago," led Atlanta's investors and homebuyers through the landmark final sale. (Christine V. Marr.)

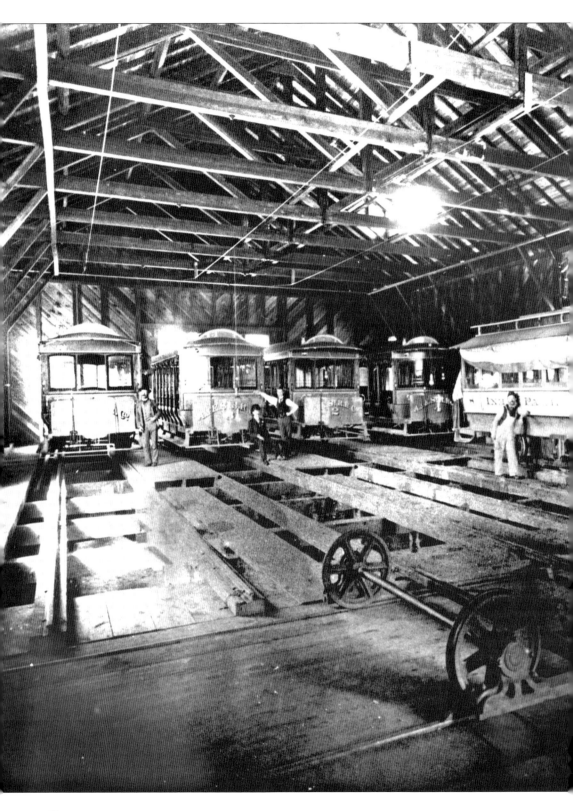

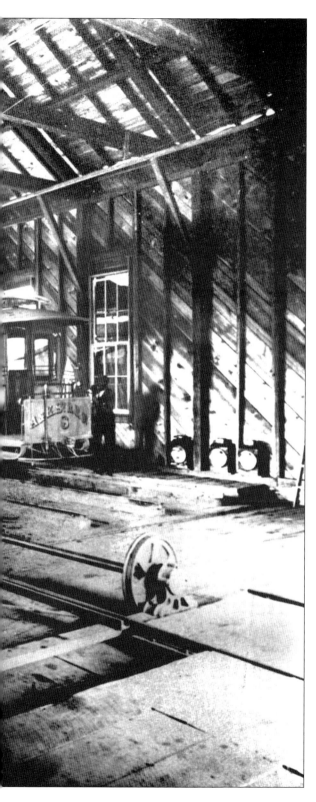

This photograph shows the interior of the Trolley Barn as it appeared in 1889. According to the *Atlanta Constitution* on August 23, 1889, "Mr. Hurt was all smiles. He was even happier than the day when the opening of Edgewood Avenue was celebrated. When the party arrived at Inman Park, he showed them through the handsome and convenient offices and carhouse of the company. Every convenience for the handling of the cars was there, and like the cars themselves, the tracks and other apparatus were all manipulated by electricity. A model street railway system in every particular." It is interesting to note the lateral positioning system engineered for placement of streetcars within the Trolley Barn. The cars entered on a single track (right) from the exterior and were then rolled to the proper lane for service and repairs. (IPNA Archives.)

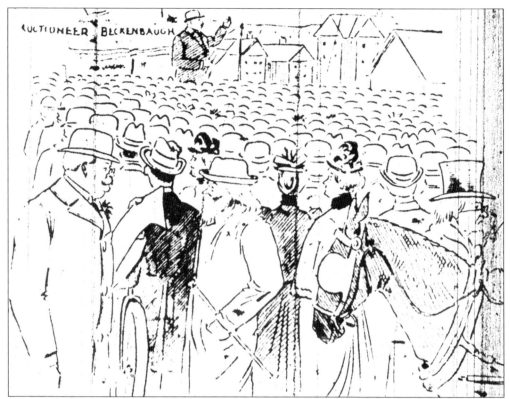

More than 400 people attended this Inman Park land auction in 1896, and 45 lots were sold for a total of $65,860 in sales. The suburb was at its peak, and the rich and powerful of Atlanta sought the exclusive lots to build large homes for their families. According to the *Atlanta Constitution* on April 9, 1896, "The bidding was spirited and the lots went at the most rapid pace possible." (Christine V. Marr.)

Springvale Park, Inman Park's central garden jewel, was completed in 1889 and reflected Joel Hurt's serious interest in horticulture. This photograph taken around 1890 looks over Crystal Lake with a view to the north. The children of Inman Park were captivated by the wildlife that took up residence in the park. (Sharon and Craig Jones.)

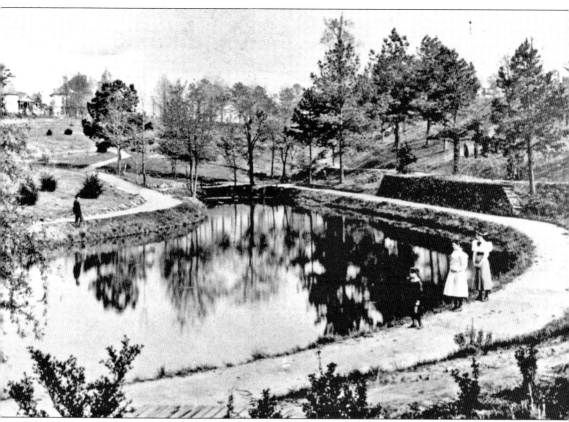

With a spectacular and unobstructed view of Springvale Park, Joel Hurt's cottage and the adjacent Gould mansion stood on the southeastern edge of the park around 1890. An *Atlanta Journal* article on February 22, 1890, reported that the park was planted with countless flowers and trees, including 116 rhododendrons and 100 azaleas from England, more than 1,000 native plants, 180 live oaks, 250 silver maples, 100 water oaks, and countless Norway maples, swamp elders, sweet gums, sycamores, sourwoods, and magnolias. The unidentified people seen here could be Hurt and his children. He often took them to Springvale Park for picnics and nature walks. Hurt was known to stage fox hunts through the vale, and surprisingly, he kept a well-tended den of foxes for that sole purpose. The park was central in physical location and in the hearts of early Inman Park residents. (Sharon and Craig Jones.)

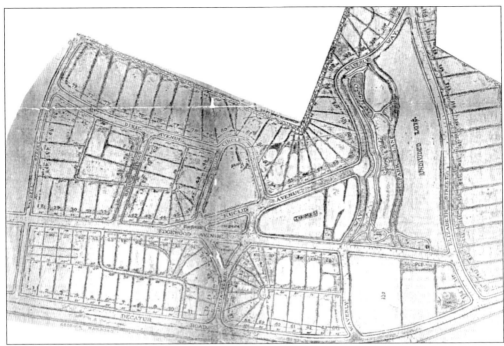

Although greatly influenced by Frederick Law Olmsted, the father of American landscape architecture, Hurt hired Joseph Forsyth Johnson to help him prepare the original landscape plans for Inman Park. Together they created a plan in harmony with the natural environment, touted by Henry Grady and others as "the ideal residence suburb." Hurt later hired Olmsted's sons in 1903 to improve upon the park. As is visible in the 1889 plat map above, Springvale Park was not separated by Euclid Avenue until the 1950s. This photograph shows Springvale Park's southern reaches near Edgewood Avenue around 1890. (Above, courtesy of IPNA Archives; below, courtesy of Sharon and Craig Jones.)

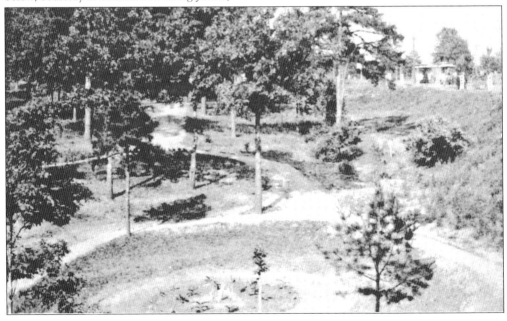

Two

THE GRAND DAMES

Atlanta's most influential families made Inman Park their home in the 1890s. As politicians, businessmen, clergymen, doctors, judges, and financiers, these men worked together to promote the good of early Atlanta. Some of the first families to invest in Inman Park included the Kings, Glenns, Candlers, LeCraws, Goulds, Harralsons, Hales, Winships, Woodruffs, and Hurts. Even today, these names are closely associated with the public service these families have contributed to the welfare of Atlanta over generations. The roster of Inman Park residents read like the Atlanta social registry itself and included the founder of Coca-Cola, the Methodist bishop and president of Emory University, two Georgia state governors, and the managing editor of the *Atlanta Journal*.

Famous architects such as Walter T. Downing, Gottfried L. Norrman, and Willis. F. Denny II were hired to design and oversee construction of the quintessential Victorian homes along the verdant avenues. High Victorian architectural styles such as the Queen Anne were en vogue at the time, and many homes included asymmetrical massing, turrets, towers, and gingerbread work. Still today, the occasional carriage step can be seen in front of these old homes to remind passersby of the days when ladies daintily alighted from carriages onto the granite blocks, while servants bustled to care for them and the horses. Over the next decade, the array of dazzling homes, lush gardens, and curvilinear avenues—not to mention the illustrious residents—made Joel Hurt's vision a reality. This ideal suburb was soon bolstered by municipal developments such as street maintenance, installation of water mains, and gas and sewer pipes, further enhancing the ease and modernity available to those who could afford it.

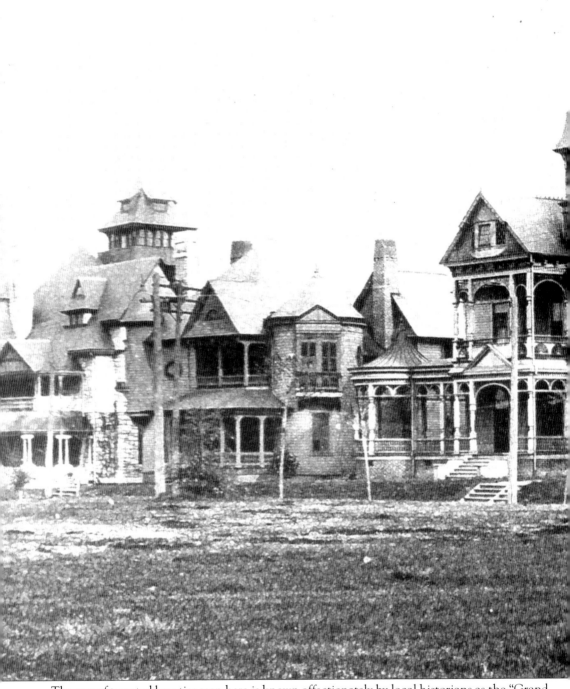

The row of turreted beauties seen here is known affectionately by local historians as the "Grand Dames," and the grandeur of these homes set the tone for what the neighborhood would become. This c. 1890 photograph shows some of the premier homes built on Edgewood Avenue following the first land lot auction in May 1889. From left to right, the homes belonged to the Harralson,

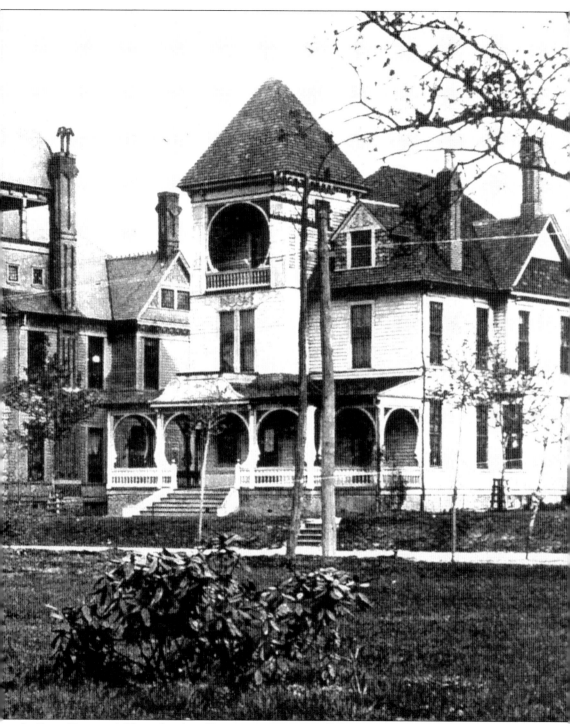

LeCraw, King, and Glenn families. Hurt was eager to install the latest utilities in his suburb too, including water, sewer, gas, and electric streetlights. At the time, these were exceptional luxuries for Atlanta—even the finest homes rarely had indoor plumbing. (IPNA Archives.)

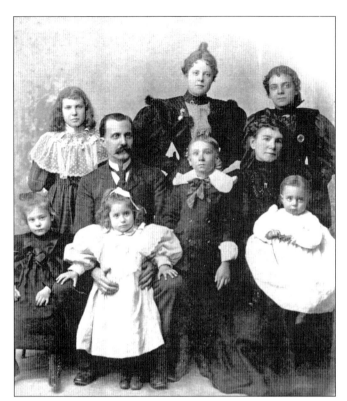

Members of the George E. King family who lived at 889 Edgewood Avenue are seen here in about 1895. King was the founder of King Hardware Company, a successful commercial operation with multiple stores throughout Atlanta. The King family included eight daughters and one son, and their family was active in the founding and support of Inman Park Presbyterian Church. (Jan and Windell Keith.)

John H. Fussell Sr. lived at 889 Edgewood Avenue as a young man. He was the son of Benjamin O. Fussell, an upper-management employee of King Hardware who bought the house from the King family around 1910. On Saturday evenings, the family rolled up the rugs, sprinkled wax on the floors, and danced. The Fussell family remained in the home until 1954. (Jan and Windell Keith.)

On the second story of 883 Edgewood Avenue, a stained-glass window still lets in the morning light after almost 120 years. Methodist minister Wilbur Fisk Glenn built this house about 1890. One of his eight children, Flora, married Charles Howard Candler, the eldest of Asa Candler's children. Glenn Memorial Church on the Emory University campus was named in Reverend Glenn's honor. (Sharon and Craig Jones.)

King Hardware advertised here in the 1921 *Atlanta Women's Club Cook Book*. The thriving business was owned by hardware magnate and Inman Park resident George E. King, who belonged to no social clubs; he believed in complete devotion to his home, work, and church. (Sharon and Craig Jones.)

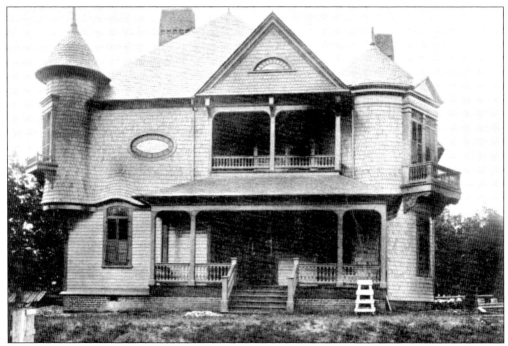

The LeCraw House is located at 897 Edgewood Avenue and was designed by architect Gottfried L. Norrman. Hurt's East Atlanta Land Company built the house speculatively in 1890, and it was rented out for the first few years of its existence. The LeCraw family rented the home for several years and bought it in 1903. (Sharon and Craig Jones.)

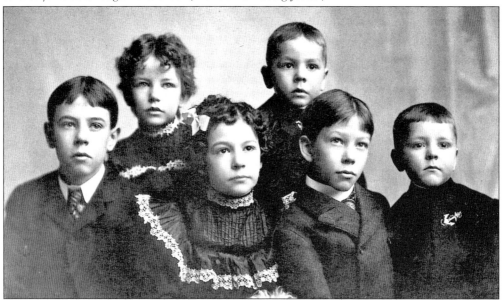

This photograph of the LeCraw children was taken about 1900. Because the family was so large, the LeCraws added a children's wing to the home, bringing the total rooms to 17, with 3 bathrooms—extravagant for their day. Roy LeCraw, who stands on the back row, was mayor of Atlanta in 1941 and 1942 but resigned to join the U.S. Army in World War II. (Virginia Rand-Hill.)

Charles Veazey LeCraw (1857–1942), pictured here in about 1900, was in the insurance business and owned 897 Edgewood Avenue during its early days of glory. After he worked for the State Life Insurance Company of Indiana for more than 40 years, the company eulogized him as a man of tireless energy, rugged honesty, loyalty, and deep devotion to duty. (Virginia Rand-Hill.)

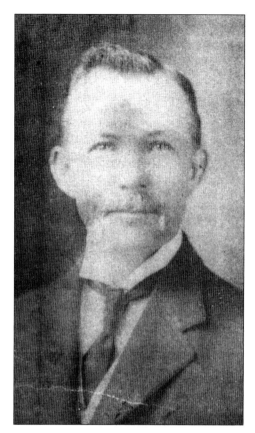

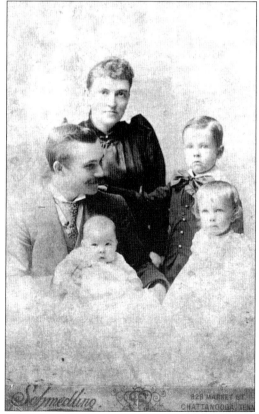

Shown here with her family around 1890, Daisy LeCraw, Charles's wife, was a music enthusiast. She and her children held violin and piano concerts in their home for Inman Park neighbors. Mrs. LeCraw was active in the Daughters of the American Revolution and started the Inman Park Students Club, a women's club that existed for more than 70 years. (Virginia Rand-Hill.)

29

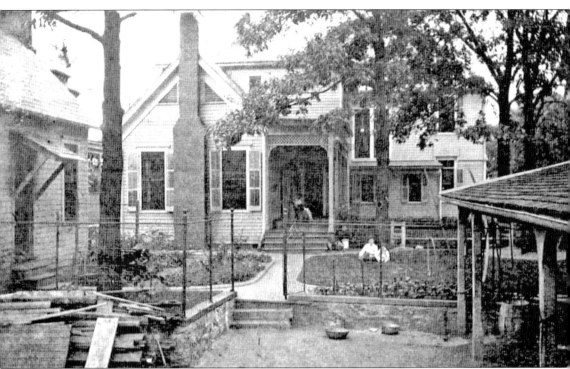

This rare rear view of a Victorian mansion shows the LeCraw home at 897 Edgewood Avenue with Walter and Arthur LeCraw sitting in the backyard around 1903. The left foreground shows the laundry building. The chimney identifies where the kitchen was, and someone—most likely the cook—sat in a rocking chair on the porch outside the kitchen. In the right foreground are the stables where horses and cows were kept. LeCraw bought the field behind the house for the livestock to pasture. In his own pictorial autobiography, John Walter LeCraw wrote of his childhood memories: "We had a carriage horse and kept him in the stable in our backyard. We had a stableman called Uncle Gabe. I think he lived in a room adjoining the stable. He took care of the horse and harnessed him to the carriage. . . . No, I never milked the cow. The cook milked her, and Gabe sometimes." In those times, even the most industrious of the upper class had servants for life's mundane chores. (Virginia Rand-Hill.)

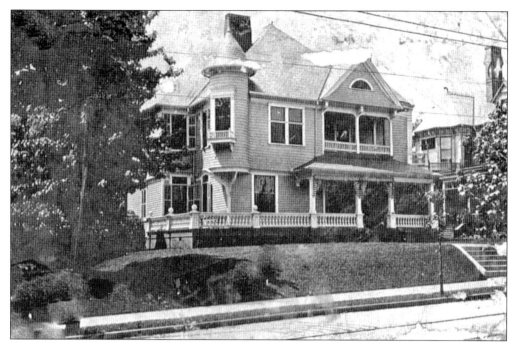

Shown here in about 1905 is the LeCraw home at 897 Edgewood Avenue. The house was about 15 years old at the time of this photograph and benefitted from the addition of an expansive wraparound porch. The photograph also shows the side of 889 Edgewood Avenue, where the George King family lived at the time. (Virginia Rand-Hill.)

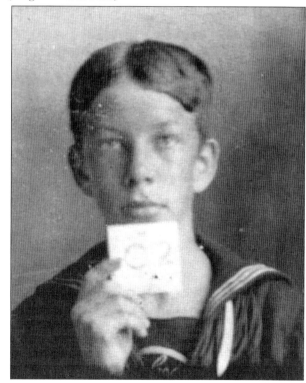

John Walter LeCraw holds a card with "02" printed on it for the year 1902. This young man grew up to become a well-known Atlanta attorney and was assistant solicitor general of Fulton County in 1941. He fought in both world wars. His early education at what was known as Inman Park Grammar School at 729 Edgewood Avenue served him well. (Virginia Rand-Hill.)

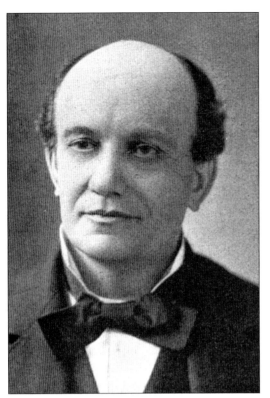

Shown here in 1895, Swedish architect Gottfried L. Norrman designed several early Inman Park buildings, including 882 Euclid Avenue, 897 Edgewood Avenue, and the school building at 729 Edgewood Avenue that is now residential lofts. Norrman also designed Ivy Hall (previously the Mansion Restaurant on Ponce de Leon Avenue), the Windsor Hotel in Americus, Georgia, and Fountain Hall at Atlanta University. (Sharon and Craig Jones.)

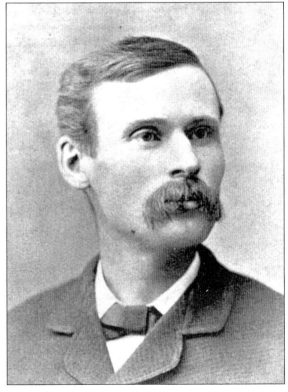

George Murphy (1850–1926) was an architect and builder. He built the Inman Park Methodist Church, Asa Candler's Inman Park home, and the Candler Building in downtown Atlanta. Murphy and his wife, Ella Holly, built their home at 33 Alta Avenue on the southern corner of Degress and Alta Avenues. He also built a house at 1063 Alta Avenue for his daughter and her husband. (Sharon and Craig Jones.)

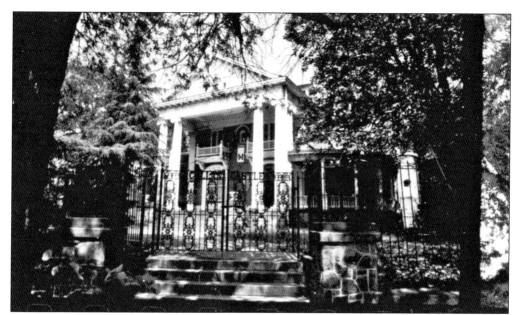

Coca-Cola founder Asa Griggs Candler lived at 145 Elizabeth Street, shown here in 1980. Built in 1902–1903 by George Murphy, this Beaux Arts home was named Callan Castle after the ancestral Candler family estate in Ireland. The lot and building costs were almost $13,000, an enormous amount in 1903. Candler hired the finest craftsmen of his time to construct the house. (IPNA Archives.)

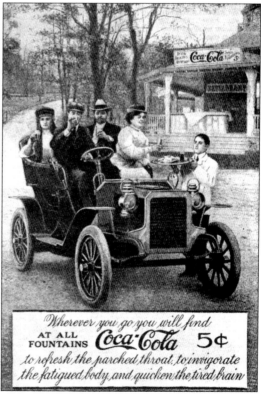

Cutting-edge advertising methods can be seen in this 1905 Coca-Cola advertisement featuring an early automobile. Asa Griggs Candler (1815–1929) came to Atlanta at age 22 with $1.75 in his pocket and built his fortune in the soft drink, which was originally used for medicinal purposes. Candler suffered from headaches and was a great supporter of the new soft drink's ability to ease pain. (Sharon and Craig Jones.)

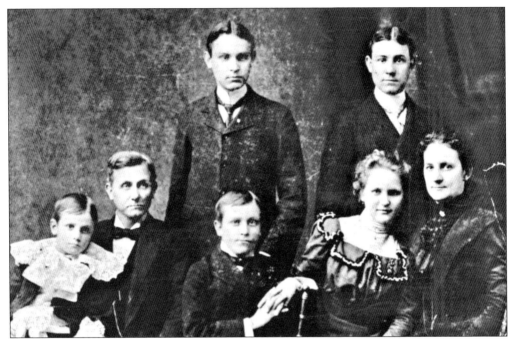

The Asa Candler family is shown here around 1895. Candler married Lucy Elizabeth Howard in 1878 and had five children: Charles Howard, Asa Jr., Lucy Beall, Walter Turner, and William. The family was close, and Candler tended his children carefully, giving them stakes in his business when they were adults. (Georgia Archives, Vanishing Georgia Collection, dek436-85.)

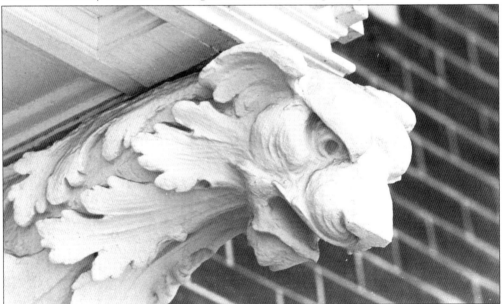

Exquisite details abound in Candler's Inman Park mansion. An exterior detail on Callan Castle's front porch, photographed in 1983, is shown here. Lucy Candler's portrait in stained glass shines over the interior stairway, and 64 electric lights glow in the foyer ceiling, encased in plaster flowers. The Candler coat of arms is depicted in stained glass on either side of the front doors. (IPNA Archives.)

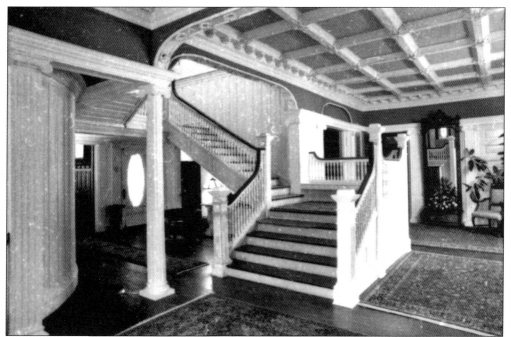

Callan Castle's foyer and grand staircase can be seen in this 1975 photograph. Four stained-glass windows were removed from the house during Inman Park's decline—two in the breakfast room and two in the dining room. They were mysteriously returned years later by an anonymous donor and have reclaimed their rightful places in the mansion. (IPNA Archives.)

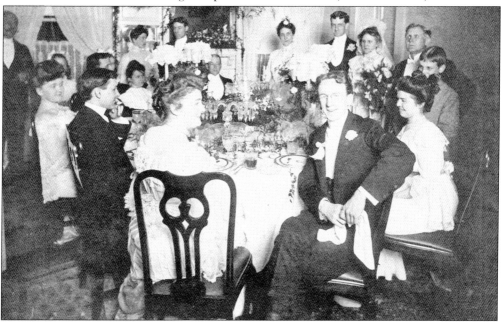

The wedding of Charles Howard Candler and Flora Glenn took place at the home of the bride's parents, Mr. and Mrs. Wilbur Fisk Glenn, on December 3, 1903, with a reception at the Candler mansion. It is believed the dining room was being used for the wedding reception, and the bridal party had a more intimate dinner in one of the downstairs bedrooms. (IPNA Archives.)

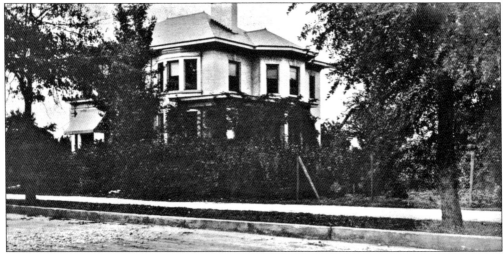

The Hurt mansion, built in 1904 and shown here about 1910, was designed by architect Walter T. Downing, whose initial architectural plans seemed too ornate to the Hurts' refined taste. This house at 167 Elizabeth Street was the Hurt family's second home in Inman Park. Hurt never left his beloved Inman Park and died in this house in 1926. (Georgia Archives, Vanishing Georgia Collection, ful0014.)

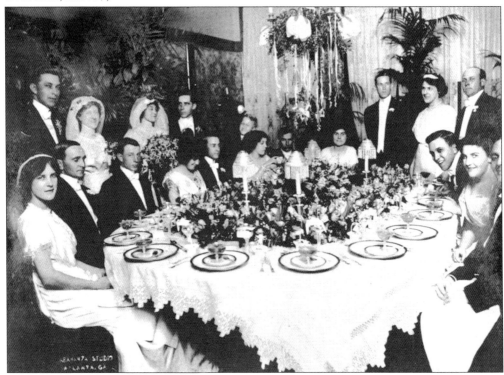

Two of Joel Hurt's daughters were married in the Hurt mansion in a double wedding on November 22, 1911. Mabel married Charles Bickerstaff, and Eva Lou married Arthur Simms. Third from right sitting is Robert Woodruff, Emily and Ernest Woodruff's son, who took Coca-Cola worldwide during World War I and was a generous Atlanta philanthropist. (Georgia Archives, Vanishing Georgia Collection, ful0018, Abananza Studios.)

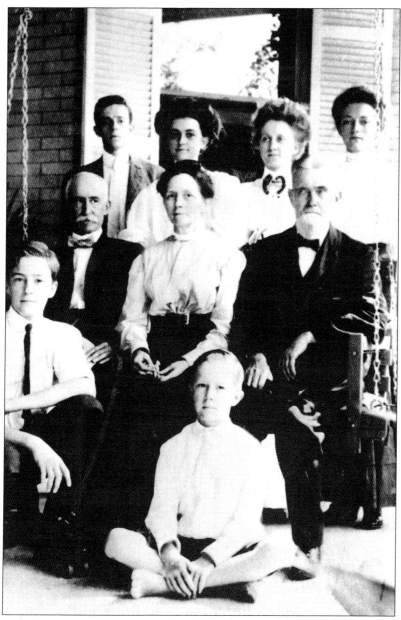

Joel Hurt and various family members gather on the front porch at 167 Elizabeth Street around 1905. From left to right are (first row) Joel Hurt Jr. and Sherwood Hurt, sons of Joel Hurt; (second row) Joel Hurt and his wife, Annie Bright Woodruff Hurt, and her father, George Waldo Woodruff; (third row) Reyburn Watres, Eva Hurt Simms, Mabel Hurt Bickerstaff, and Gertrude Lovell. The Hurt couple was known to family members as Joe and Brightie, and their love of family was reflected in the number of relatives that resided with them. They were parents of six children: George, Virgilee, Mabel, Eva Lou, Joel Jr., and Sherwood, although Virgilee did not live to adulthood. The Hurts also raised their niece, Louise Bright Rowe, as their own child. Both Joel's mother and Annie Bright's mother lived with them in their final years. The Hurt children were close to their cousins, Ernest and Emily Woodruff's three sons, and often played with them in Springvale Park. (Georgia Archives, Vanishing Georgia Collection, ful0015.)

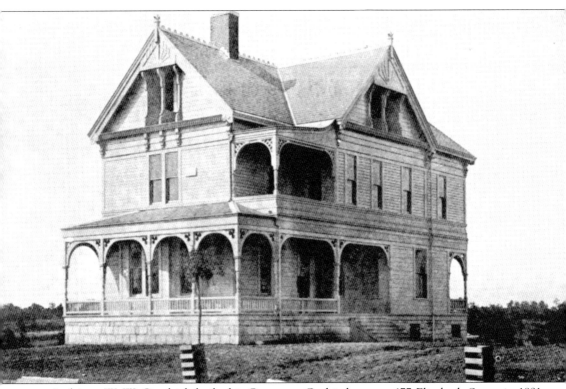

Architect W. W. Goodrich built this Carpenter Gothic house at 177 Elizabeth Street in 1891 for William Corey Hale at a cost of $5,500. Hale was a prominent Atlanta businessman and president of two banks. With his two brothers, Moses and Dayton Hale, he started the Hale Investment Company, which bought, sold, and developed housing for low-income buyers. Some of this housing was on the edge of Inman Park and is now included in the Inman Park Historic District. In 1897, William Hale was involved in a shady business deal and fled the state of Georgia. He never returned, although his brothers and his mother remained and were solid members of the community. Hale sold this house to Benjamin Harvey Hill Jr., whose father was famous U.S. senator Ben Hill. It is not known whether the shadowy figure on the front porch is W. W. Goodrich or William Hale. (Sharon and Craig Jones.)

Originally from Mississippi, William C. Hale became a successful businessman in Atlanta. It can be ascertained from Joel Hurt's comments in the newspapers of the day that he was not fond of his neighbor, and rightly so, as Hale became an infamous white-collar criminal in Atlanta in the late 1890s. (Sharon and Craig Jones.)

Shown here in 1895, Benjamin Harvey Hill Jr. was a successful attorney and chief judge of the Georgia Court of Appeals from 1907 to 1913. His house at 177 Elizabeth Street was the first house built on the northern part of the street after crossing Euclid Avenue. (Sharon and Craig Jones.)

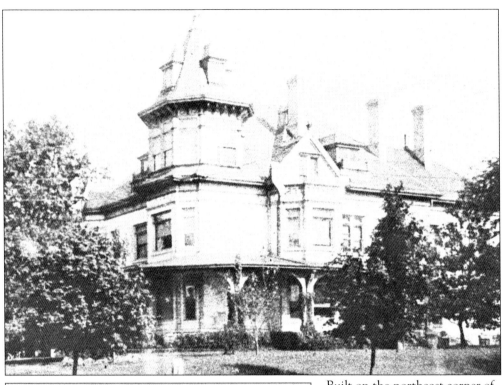

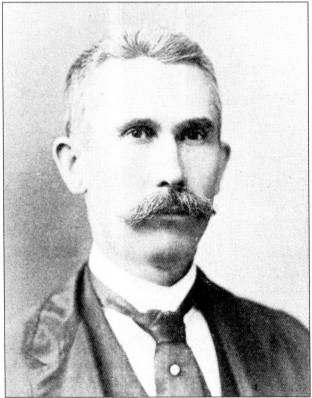

Built on the northeast corner of Elizabeth Street and Edgewood Avenue for Erastus Franklin Gould, this house was made of Georgia marble and was torn down in the 1940s. Gould was a businessman and capitalist and owner of the Gould Building, designed by W. W. Goodrich. Marble from Gould's Marble Palace lines the driveway and basement of the adjacent Hurt Cottage today. (IPNA Archives.)

Shown here in 1895, Philip H. Harralson was an investor in Joel Hurt's East Atlanta Land Company. Harralson was one of the first to buy land and build a home on Edgewood Avenue. His home was the largest of the Grand Dames and looked out on the Mesa, an expansive open park space that was later subdivided and developed. (Sharon and Craig Jones.)

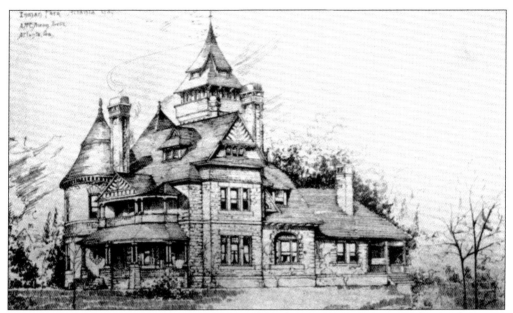

Philip H. Harralson's 1890 mansion was located on the southwest corner of Edgewood Avenue and Waverly Way. The house was damaged by an interior fire in the mid-20th century and subsequently destroyed. Two modern houses now stand on the property, but the massive granite stairs from the sidewalk remain as a reminder of the grandest of the Grand Dames. (Above, courtesy of Sharon and Craig Jones; below, courtesy of Pat and Wayne Smith.)

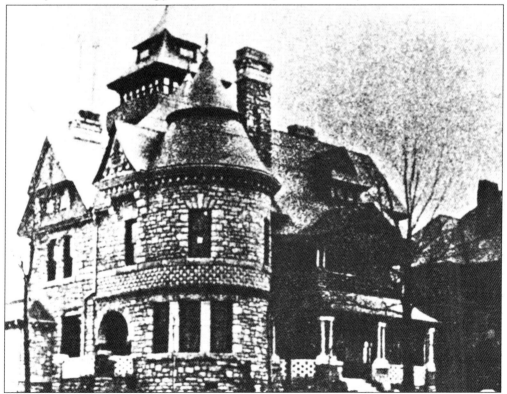

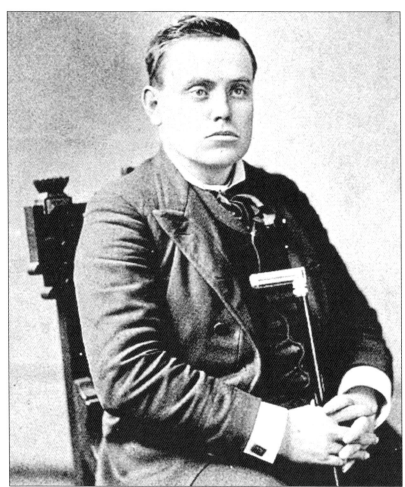

Warren A. Candler, photographed in 1891, served as president of Emory College in Oxford, Georgia, and as bishop of the Methodist Episcopal Church South. Candler influenced his brother, Asa, to donate $1 million to the founding of Emory University in Atlanta. A letter accompanied the funds, a portion of which is shown below. It reads, "In humble trust in the Christ to whom I look for salvation, I dedicate the means with which Providence has blessed me to the up-building of the Divine Kingdom. In confidence that my brethren and fellow-citizens of Atlanta, Georgia and of our Southern Methodist connection will join with the Commission in carrying this great enterprise to speedy and large success, I offer this contribution to its foundation." (Above, courtesy of Sharon and Craig Jones; below, courtesy of the Inman Park United Methodist Church archives.)

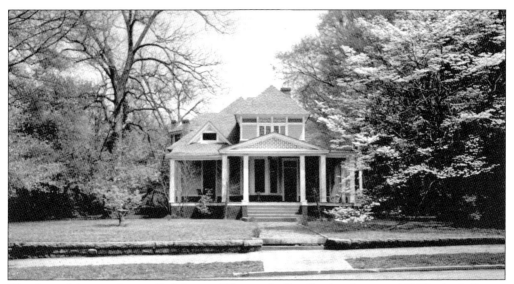

The first of the two Inman Park houses Warren A. Candler lived in was 137 Elizabeth Street, located next door to his brother Asa Candler's house. Built about 1892, it is considered to be a Queen Anne cottage. During Inman Park's decline, the house was used as an elderly men's home. (Sharon and Craig Jones.)

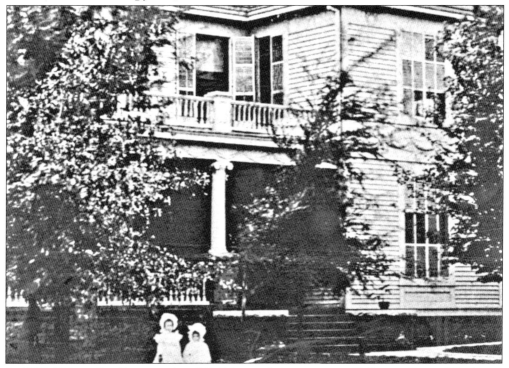

In 1908, Bishop Candler moved to 790 Edgewood Avenue, now 56 Spruce Street. The house was built in the early 1890s for Charles R. Winship, son of Robert Winship and brother of Emily Winship Woodruff, when he was vice president of Winship Machine Company. Winship had three daughters: Emily, Ida, and Frances. Two of his daughters are shown here in 1897. (Kenan Research Center at the Atlanta History Center.)

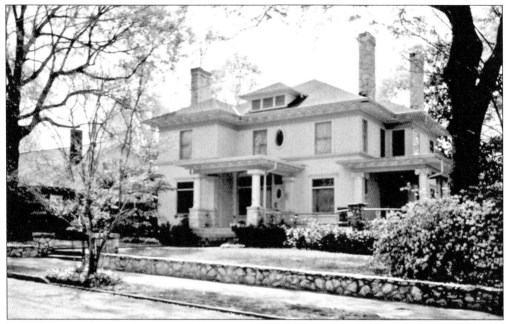

Charles Howard Candler, Asa Candler's eldest son, built this house at 188 Elizabeth Street in 1907. He had married Flora Glenn four years before and had been living with his in-laws at 883 Edgewood Avenue. Charles and Flora had three children. In 1920, Candler built and moved to Callanwolde on Briarcliff Road in Atlanta. (Sharon and Craig Jones.)

Shown here is Charles Howard Candler's 1898 senior class photograph from Emory College at Oxford. Candler was twice president of the Coca-Cola Company, and he was chairman of the board of trustees of Emory University from 1929 until his death in 1957. He and his wife were great benefactors to Emory University. (Sharon and Craig Jones.)

John R. Dickey, an Atlanta businessman who worked for the Georgia Stove Works, lived at 866 Euclid Avenue after John M. Beath's short tenure in the house. He is shown here in 1895. The Dickey family occupied the house for several decades. The architect of this house is unknown; however, it is believed the exterior color has always been red. (Sharon and Craig Jones.)

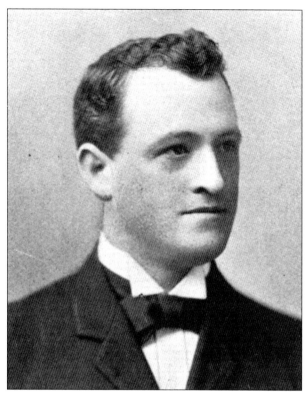

The cover photograph, known by local historians as the "Tea Party" photograph, was taken about 1900 at the Beath-Dickey-Griggs house at 866 Euclid Avenue when the Dickeys made this Queen Anne Victorian their home. The house was originally built in 1890 for John M. Beath, president of Atlanta Ice and Coal, as a wedding present for his wife. (Robert Griggs.)

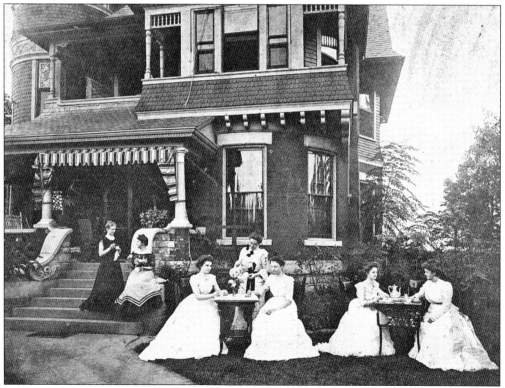

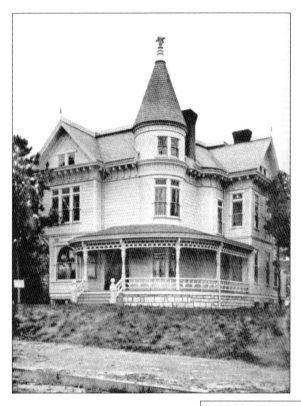

Ernest and Emily Woodruff lived at 882 Euclid Avenue for about 10 years until they moved into their second Inman Park house at 908 Edgewood Avenue. Ernest Woodruff's sister was married to Joel Hurt, who enticed Woodruff to move to Atlanta from Columbus, Georgia, and run the new electric trolley company. Ernest's father, George Woodruff, bought the house for the young family. (Sharon and Craig Jones.)

Architect Gottfried L. Norrman designed the house at 882 Euclid Avenue for the East Atlanta Land Company to sell on speculation in 1890. This photograph shows the majestic detailing of the turret ornament. The Ernest Woodruff family referred to this house as their "small" house. (IPNA Archives.)

Shown here in 1885 just prior to moving to Inman Park from Columbus, Georgia, Ernest Woodruff was a shrewd Atlanta businessman as president of the Atlanta and Edgewood Street Railway Company and as president and chairman of the board of the Trust Company. He negotiated the sale of the Coca-Cola Company in 1919, and his son Robert W. Woodruff put Coke on the global map. (Della Wager Wells.)

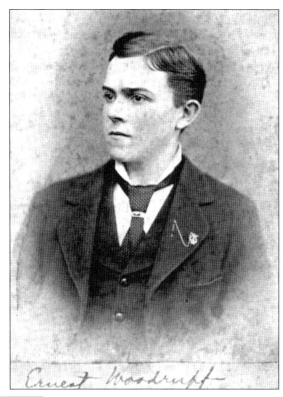

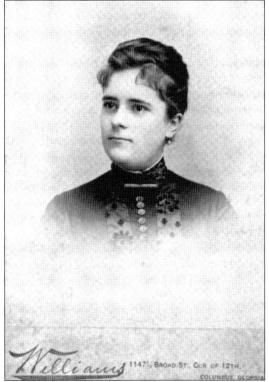

Emily Winship Woodruff, shown here in 1885, was wife of Ernest Woodruff and mother of three sons: Robert, George and Henry, all of whom were raised in Inman Park. Her parents were Robert and Mary Francis Winship of 814 Edgewood Avenue; her father was the founder of Winship Machine Company. Emily was known for her devotion to her family and did not associate in social groups. (Della Wager Wells.)

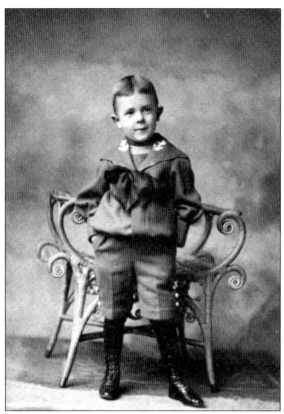

George Waldo Woodruff, named after his paternal grandfather, was born in 1895 at 882 Euclid Avenue. He was the middle son of Ernest and Emily Woodruff and was four years old when this photograph was taken in 1899. George and his Hurt cousins drove goat carts through Victorian Inman Park as children. His adulthood was marked with excellence in business and generous philanthropic interests. (Della Wager Wells.)

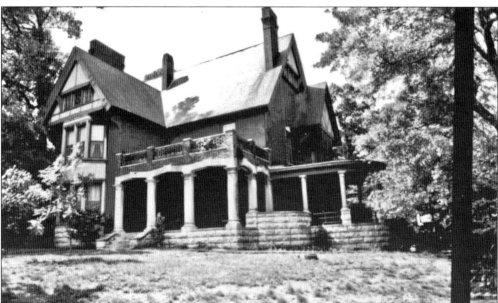

This 26-room house at 908 Edgewood Avenue was the second Inman Park home of Ernest and Emily Woodruff and their sons. The Woodruffs moved into the house, designed by architect Walter T. Downing, around 1902. The grounds of the house included stables and tennis courts on the open land adjacent to the house, originally called the Mesa. (IPNA Archives.)

Dr. Charles Davis Hurt, Joel Hurt's brother, moved to 36 Delta Place around 1891. Originally from Alabama, he came to Atlanta when his brother asked him to serve as physician for the Atlanta and Edgewood Street Railway Company. Dr. Hurt married Louise Grant and had eight children, six of whom lived to adulthood. He was instrumental in founding Emory University Hospital. (Sharon and Craig Jones.)

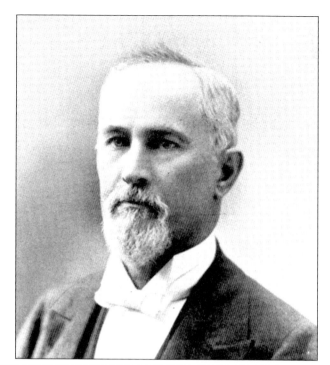

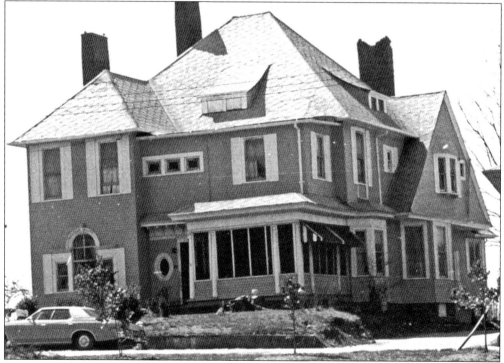

Seen here in the mid-1970s, 36 Delta Place was the home of the Dr. Charles Davis Hurt family. It is said Charles Hurt did as much for the medical community as Joel Hurt did for the development of Atlanta. His son-in-law founded Crawford Long Hospital. The house was built in 1891. (IPNA Archives.)

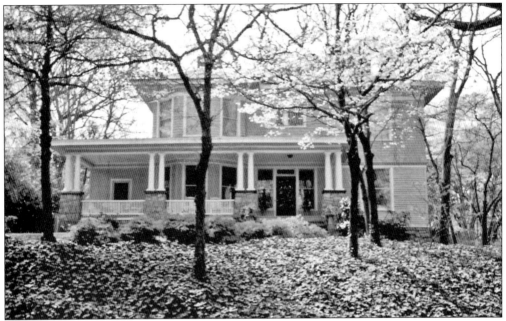

The house shown here at 126 Waverly Way was home to Aaron Haas. It was built in 1907, and the architect is unknown. The Haas family was one the first Jewish families in Atlanta, tracing back to the 1840s. Haas was Atlanta's first mayor pro tem in 1875. (Sharon and Craig Jones.)

The structure at 140 Waverly Way is the only house in the neighborhood totally designed by beloved Atlanta architect Joseph Neel Reid, who trained under Willis F. Denny II. The house was built in 1914 for E. R. Haas next door to his father Aaron's house, and it is seen here in 1977. (IPNA Archives.)

A native of Germany, Aaron Haas was rumored to have been a blockade runner for the South during the Civil War. Haas was involved in numerous Atlanta businesses, including a trolley company that competed with Joel Hurt's company, and one of Atlanta's oldest insurance companies, the Haas-Howell Company. (Sharon and Craig Jones.)

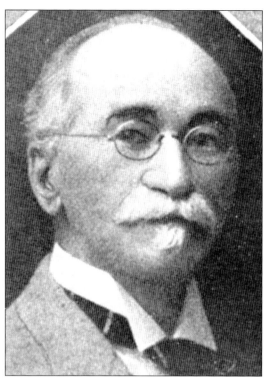

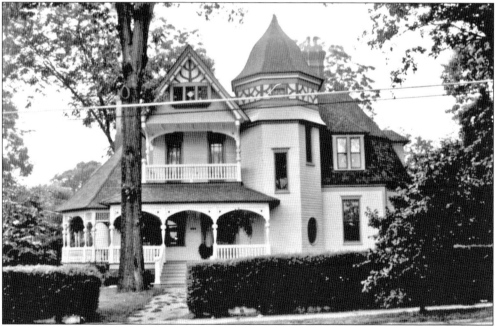

Seen here in 1980, this house at 804 Edgewood Avenue was one of the earliest in Inman Park and was built by attorney Thomas W. Latham around 1890. It was later purchased by Joseph F. Greenfield, known for his influence in Atlanta's Masonic circles. The house was once divided into 13 apartments, but today it is thoroughly restored as a bed-and-breakfast inn. (Pat and Wayne Smith.)

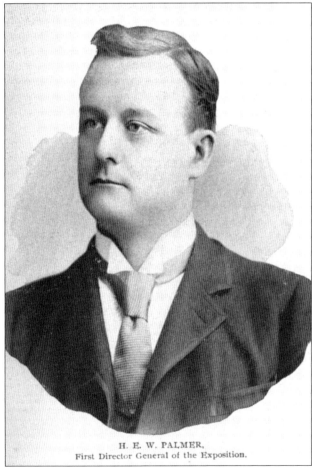

H. E. W. PALMER,
First Director General of the Exposition.

Judge Howard E. W. Palmer built this house at 482 Seminole Avenue. Palmer, shown left in 1895, was a prominent Atlanta businessman and lawyer. He was a judge in Burke County, Georgia, for only one year when he was 22 years old, but the title remained with him throughout his life. Palmer's professional background was powerful, including the following titles: secretary of the executive department of Georgia, assistant district attorney for the Northern District of Georgia, director general of the 1895 Cotton Exposition, personal attorney for Joel Hurt and Asa Candler, and legal counsel for the Southern Bell Telephone Company, where he died at his desk in 1921. Judge Palmer owned a number of lots near where he built his own house about 1915, reportedly with chain gang labor. Palmer was known for his fine physique. (Both images courtesy of Sharon and Craig Jones.)

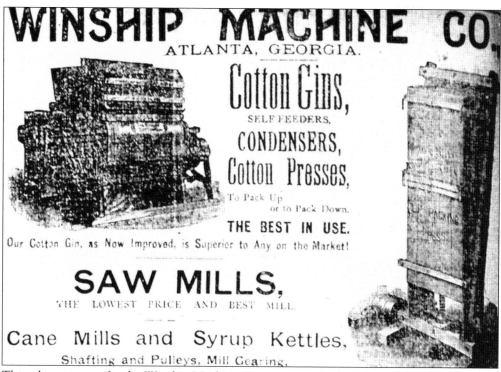

This advertisement for the Winship Machine Company ran in the *Atlanta Journal* on April 24, 1889. The iron works company was owned by Robert Winship and his son, Charles R. Winship of 790 Edgewood Avenue. During the Civil War, the company manufactured guns for the Confederacy. The Winship Machine Company was burned by General Sherman's soldiers and rebuilt after the war into one of Atlanta's most important industries. (Christine V. Marr.)

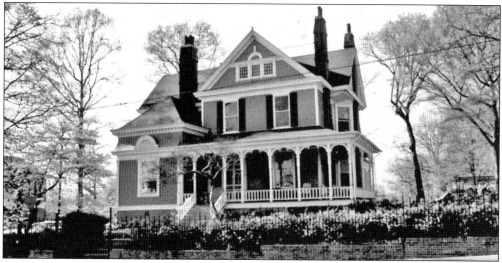

Robert and Mary Frances Winship built this house at 814 Edgewood Avenue in the 1890s, and it is shown here in 1980. The Woodruff children had fond memories of walking to school past the Winship house, with their grandmother waving from its handsome windows. Originally the house was painted maroon with black trim and was considered exceptionally attractive. (Pat and Wayne Smith.)

Architect Willis Franklin Denny II appears here around 1900. He attended Col. Asbury F. Moreland's military academy on Moreland Avenue, where he met his future wife, Colonel Moreland's daughter Gertrude. After graduating from Cornell University, Denny returned to Atlanta and designed the Inman Park Methodist Church, the Hebrew Synagogue, the Kriegshaber House, St. Mark's Methodist Church, First Methodist Church, and Rhodes Hall, plus several other frame houses in Inman Park. Denny's own house was located on Moreland Avenue near the Little Five Points business district and was destroyed in the 1940s. Seen here is an interior photograph Denny's home around 1900. Unfortunately he died at the early age of 31 in 1905, depriving Atlanta of his remarkable talent. (Both images courtesy of the Inman Park United Methodist Church archives.)

Three

A COMMUNITY OF FAITH

Religion was central to the lives of early Inman Park residents, and several denominations found a home in the Victorian suburb. Since its erection in 1898, the Inman Park Methodist Church has defied the passage of time: bells peal throughout the neighborhood on the half hour, and the soaring Stone Mountain granite walls serve as a beacon to gather the community together inside for meetings, schools, and of course, worship. Inman Park Methodist was built on a solid foundation of faith and Coca-Cola money and still serves a small and devoted congregation.

Various other churches rose among the green parks and mansions of Inman Park and eventually dissipated after serving the community. The Presbyterians claimed their stake in the neighborhood as well with the now vanished Inman Park Presbyterian Church. Its members met at several sites throughout Inman Park and eventually melded into Druid Hills Presbyterian Church on Ponce de Leon Avenue nearby. The Baptists were not to be ignored and worshipped in the defunct Trolley Barn. They built a magnificent church on Hurt Street that was demolished during Inman Park's decline.

The Church of the Epiphany, an Episcopal church, was established in 1898 right in the middle of today's Little Five Points business district on the eastern edge of Inman Park. It moved to its Seminole Avenue location in Inman Park as its members grew. In 1957, as the neighborhood declined, the Church of the Epiphany relocated a third and final time to its present address on Ponce de Leon Avenue. St. Hilda of Whitby on North Highland Avenue tolls its Sunday bells since it was consecrated as an Anglican Catholic church in 1979.

With the invention of the automobile, the necessity of a neighborhood church became outdated. Inman Park residents of today are members of church congregations all over the city, and the residents pride themselves on their diversity in religion and all aspects of humanity. The few surviving church buildings are well-loved by the community and still serve their congregants in small numbers or have been converted to residential living space.

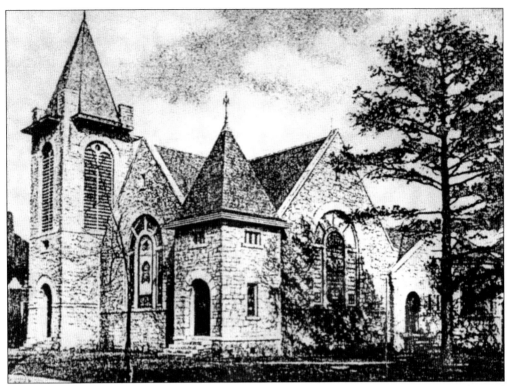

Inman Park Methodist Church was formerly named Edgewood Methodist and was located on Seaboard Avenue. Its Inman Park location was completed in 1898. (Inman Park United Methodist Church Archives.)

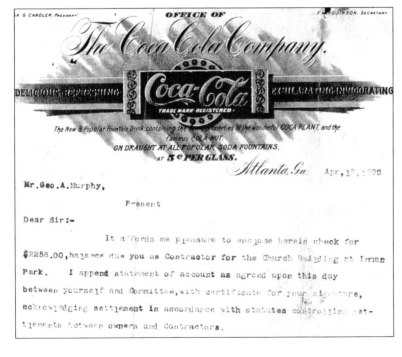

In a letter to builder George Murphy, Coca-Cola founder Asa Candler forwards the final payment for his construction services. Murphy had put a low bid in to complete the construction for $7,500. The total cost to build the church was $12,620. (Inman Park United Methodist Church Archives.)

After the church took almost two years to build, the dedication ceremony took place in April 1898. The Romanesque-style church was built of Stone Mountain granite with a blue and black slate roof. The original pews and podium remain unchanged today. Architect Willis F. Denny II designed the building. (Inman Park United Methodist Church Archives.)

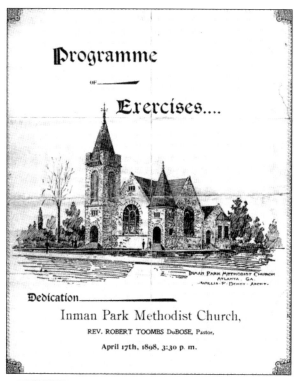

David and Sarah Seitz, shown here around 1880, were pioneer Atlantans and early founders of Inman Park Methodist Church. After the Civil War, they held church services in a nearby brush arbor. The stained-glass window of the church facing Edgewood Avenue is dedicated to their honor. Sarah Seitz removed the first shovel of dirt at the site of the new church. (Inman Park United Methodist Church Archives.)

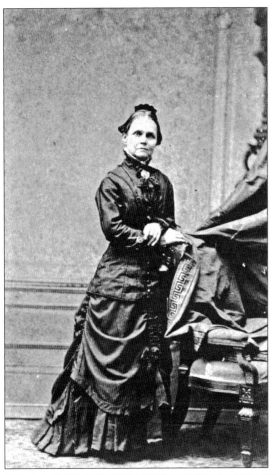

Three of Martha Bernetta Beall Candler's children gained fame in the 19th century: Asa as founder of Coca-Cola, Warren as a Methodist bishop, and John as a Georgia Supreme Court justice. Asa provided the newly built Inman Park Methodist Church with a large stained-glass window dedicated to his mother's memory; she had recently died in 1897. Located on the eastern wall of the sanctuary, it reads, "She hath done what she could." The receipt is included here, which shows Candler purchased the window for $125. A photograph of this famous mother is shown to the left. (Left, courtesy of the Georgia Archives, Vanishing Georgia Collection, dek431-85, Motes; below, courtesy of the Inman Park United Methodist Church Archives.)

V. E. Orr & Company,

DESIGNERS, DECORATORS AND MANUFACTURERS.

ART AND DECORATIVE GLASS.

School Furniture and Supplies, Church Furniture, C. H. Furniture and Opera Chairs.

Atlanta, Ga. *April 15* 189*8*

SOLD TO M*r Asa. G. Candler*

TERMS

No. Lights.	SIZE	NO. FEET.	PRICE.	
1 Art Glass window			$125 00	
		Paid	*V E O & Co.*	

A few of the church's original receipts from the 1898 construction still exist. This one from Hunnicutt and Bellingrath Company is filled with interesting details. At the top, it is written, "Take bill to A. G. Candler." The bill was later paid by donation. The workers' carfare to the church was 20¢. (Inman Park United Methodist Church Archives.)

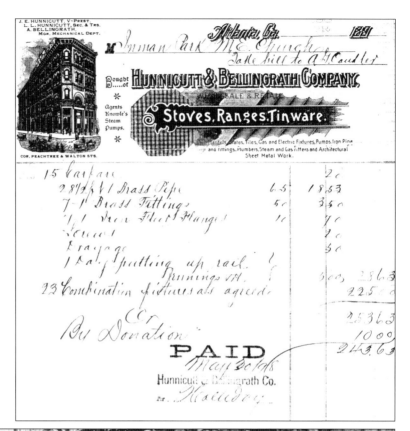

Tom Thumb was the stage name for Charles Stratton, a man of diminutive stature. He made his debut in the circus in 1843 and garnered great attention when he married Lavinia Warren, an even smaller person, in 1863. This Tom Thumb wedding, which took place around 1920, was a fund-raiser for an Inman Park Methodist Sunday school class. (Inman Park United Methodist Church Archives.)

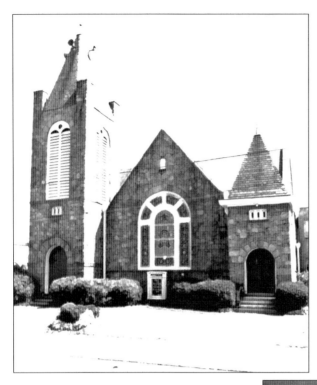

The Inman Park Methodist Church is shown here as it appeared in 1975. Additions were made on the Dekalb Avenue side in 1922, and in 1925, the rock building adjacent to the sanctuary was added. Today, besides serving a small congregation, the church is a popular setting for weddings, with the restored Trolley Barn nearby to host receptions. (IPNA Archives.)

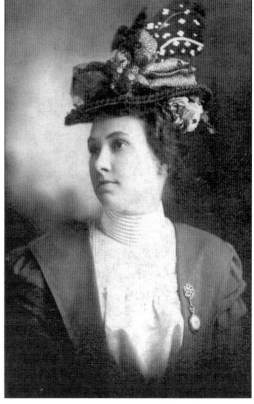

Annie Lou Harralson Pritchett was the daughter of Madison Harralson, owner of the Oaks, a large house that was located on what would later become Harralson Avenue. Shown here in her wedding gown on April 27, 1898, Annie Lou was the first bride at Inman Park Methodist Church. Her wedding dress was green. (Inman Park United Methodist Church Archives.)

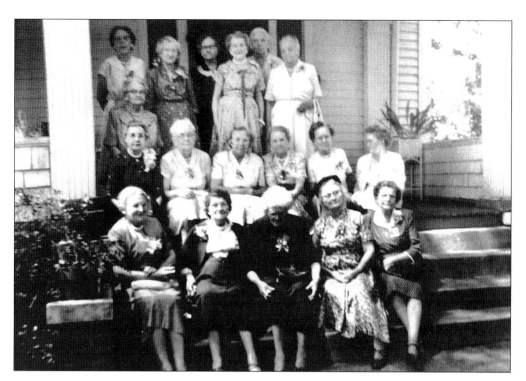

The ladies of Inman Park Methodist Church's Harris class pose here around 1950. The Sunday school class was named after Florence Candler Harris, Asa Candler's sister. This photograph was taken on the porch of Mrs. T. L. Bond's house at 782 Dixie Avenue, which has since been demolished. Her daughter, Sarah Bond, lived at that address as a child, and someone—most likely her parents—contributed to the Founder's Club of Emory University in her name when she was eight years old in 1916. Bishop Warren A. Candler's signature can be seen on the certificate. (Inman Park United Methodist Church Archives.)

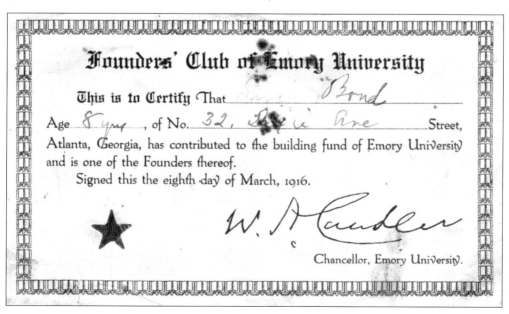

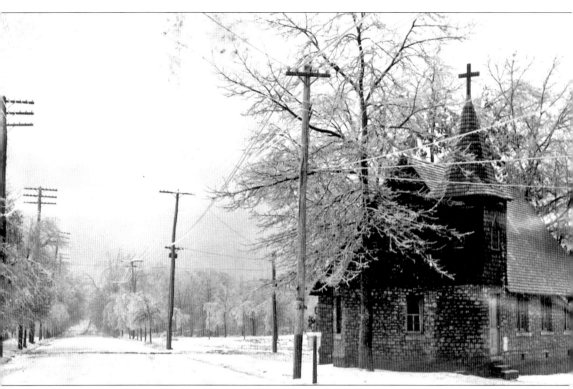

This wintry image of the back side of the Church of the Epiphany was taken in 1905, looking south on Moreland Avenue. Built in 1898, this was the first location for the church, which was located in what is now the heart of the Little Five Points business district inside the triangle formed at Euclid, McClendon, and Moreland Avenues. There were no stores in the Little Five Points business district and no houses along Moreland Avenue at the time. Today's tattoo parlors, t-shirt stores, and skateboard shops of Little Five Points would have been unimaginable to the early members of this church. The church was expanded at this location in 1906 and in 1917 to serve its growing needs. In 1922, the church lot was sold to Gulf Oil for $24,500, and the parish bought an assemblage of lots on Seminole Avenue, where they constructed a larger brick church building. (Episcopal Church of the Epiphany.)

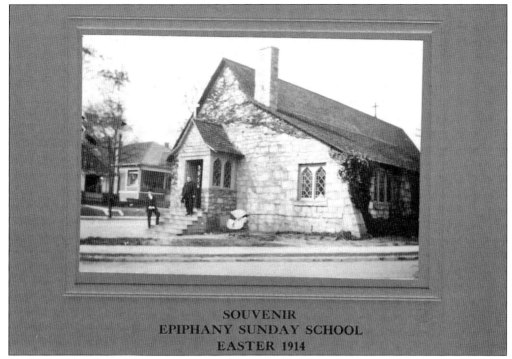

SOUVENIR
EPIPHANY SUNDAY SCHOOL
EASTER 1914

The Church of the Epiphany's front entrance is seen here with housing in the background along Euclid Avenue. The rector was forced to stop his sermons when the streetcars went by, which was often as several lines passed the church. An old-style baby carriage is parked on the front lawn. (Episcopal Church of the Epiphany.)

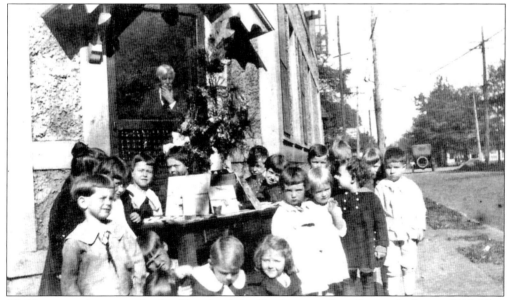

Children pose here outside the Church of the Epiphany in their Easter clothes in 1916. This photograph was taken outside of the church's 1906 addition on the southern side of the original building. Looking north on Moreland Avenue, an automobile can be seen headed toward Ponce de Leon Avenue. (Episcopal Church of the Epiphany.)

In 1923, the Church of the Epiphany parish moved to nearby Seminole Avenue, its second location in Inman Park. Seen here in about 1950, the church was thriving and had bought a rectory next door to the church in 1937. It also owned a community playground in a field behind the building. (Episcopal Church of the Epiphany.)

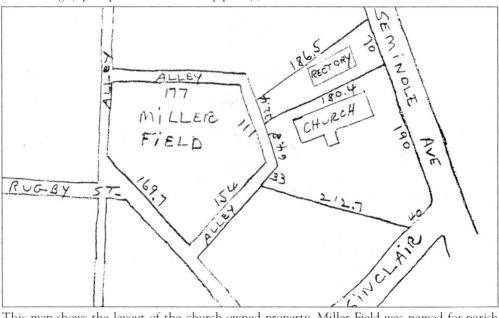

This map shows the layout of the church-owned property. Miller Field was named for parish member John M. Miller. Today the church building is owned by the St. Joseph Maronite Catholic Church, an Eastern rite of the Catholic church with more than 250 families in its congregation. The rectory was sold and is in private residential use, but the field is still church grounds. (Episcopal Church of the Epiphany.)

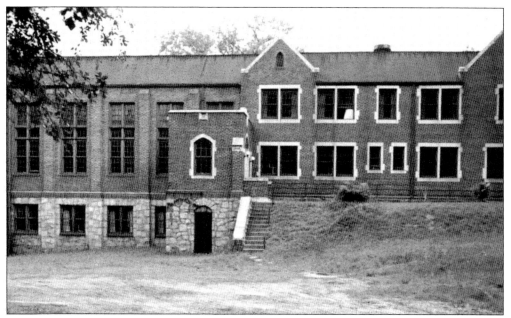

On the south side of the Church of the Epiphany is a parking lot, shown here unpaved in 1950. The parish moved a second time in 1956 to a location on Ponce de Leon Avenue, where it continues as an active member of the community. The congregation still includes a few Inman Park residents, a vestige of the church's 58-year history in the neighborhood. (Episcopal Church of the Epiphany.)

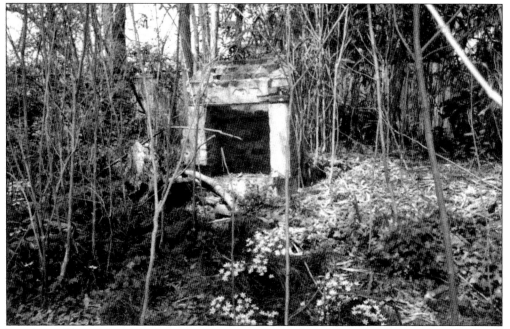

Boy Scout Troup No. 19 built a "scout hut" on the northern edge of Miller Field in the 1920s, and all that remains of the hut is a fireplace in the woods. The current church generously allows the local children to play in the field today. This hidden green spot has echoed with the laughter of children for more than 80 years. (Sharon and Craig Jones.)

This is to Certify that

Edna Lynn Turner

is a GODPARENT to

Nancy Anne Naylor

who was Born *August 1,* 194 *7*

and who became

A MEMBER OF CHRIST
THE CHILD OF GOD, AND
AN INHERITOR OF THE
KINGDOM OF HEAVEN
through

HOLY BAPTISM

in *Church of The Epiphany*
(CHURCH)

Atlanta, Georgia
(CITY)

on *April 2,* 19 *50*

Other Sponsors *Velma Cannon Hillburn*

William S. Hillburn

(Signed) *Waddell F. Robey*
Rector

Nancy Ann Naylor was baptized on April 2, 1950, at the Church of the Epiphany by Waddell F. Robey, rector. Little Nancy is author Christine V. Marr's mother. The family has roots in Atlanta, and particularly in Inman Park, although they now reside in Virginia. (Christine V. Marr.)

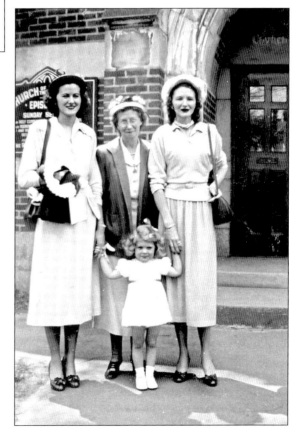

Following the Holy Baptism of three-year-old Nancy Naylor in 1950, family members posed outside of the Church of the Epiphany; its front signage can be seen in the background on the left. From left to right are Miriam C. Turner Naylor, Luna E. Turner Aderhold, and Edna Lynn Turner. (Christine V. Marr.)

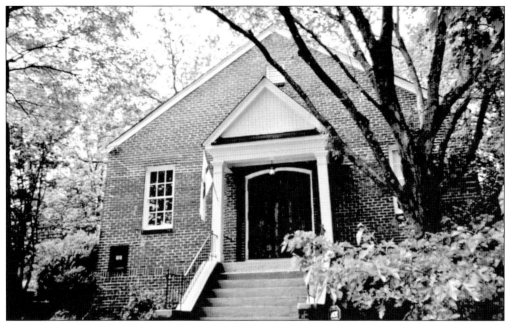

St. Hilda of Whitby, an Anglican Catholic church, was built at 414 North Highland Avenue in 1939 as a Primitive Baptist church. Gen. Leonidas Polk, known as the "Fighting Bishop" of the Confederacy, is considered a saint in this church. He was the last Anglican bishop to be killed in combat, and relics from his Civil War field communion chest are enshrined inside the church. (Sharon and Craig Jones.)

Known affectionately and inexplicably to Inman Park residents as Lizzie Chapel, this vacant church on the eastern corner of where Druid Circle meets Euclid Avenue was built in 1930 for the Atlanta Gospel Tabernacle. The parking lot once held the Inman Park Presbyterian Church, which Inman Park founders such as the Kings, Hales, and Hurts attended. (Sharon and Craig Jones.)

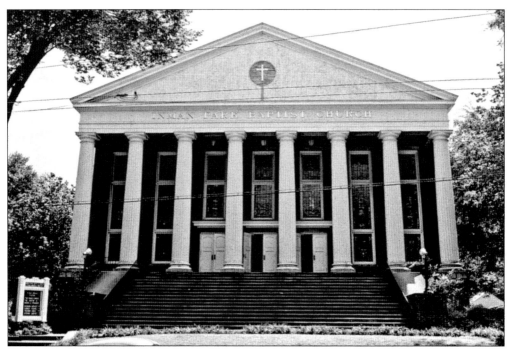

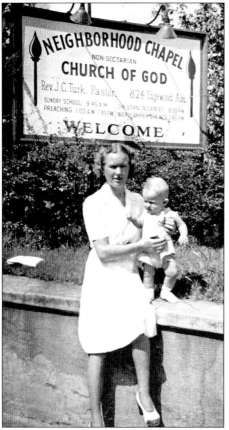

Stately and traditional, the Inman Park Baptist Church appears here in 1950. It was located on Hurt Street in Inman Park near the present-day MARTA rapid rail station. The services were originally held in the Trolley Barn on Edgewood Avenue that was already assuming a state of disrepair. (Special Collections and Archives, Georgia State University Library.)

The Neighborhood Chapel Church of God, a non-sectarian group, was located at 824 Edgewood Avenue. Little is known about this church that, like many others in Inman Park's long history, rose up to serve the neighborhood and then disappeared into oblivion. This photograph was taken in 1943. (Mrs. Joseph Edward Bowers.)

Four

THE TURNING POINT

In 1910, the residential deed restrictions lapsed, marking a turning point in the Inman Park story and the swift exodus of many of the well-known residents. Almost immediately, commercial establishments sprang up, as did apartment buildings. Little Five Points grew to distinction as the largest regional shopping district of the era due to the intersection of three streetcar lines at that point, and profit-minded builders took notice. They purchased land lots and then subdivided to build multiple smaller homes of cheaper materials with less space between the houses. Middle-class families rushed to the neighborhood. A wide variety of other homes, some grand and some more modest, were built throughout the neighborhood during these years—bungalow, American foursquare, and folk Victorian.

Over the following decades, Inman Park became more as we know it today—an amalgamation of mini-neighborhoods cohesively united by their love of the pastoral parks and ease to downtown. It became a neighborhood of contrasts, where an esteemed Joel Hurt could live merely blocks from middle-class employees of the Atlanta Stove Works. Inman Park acquired the blendedness unique to urban life.

The Great Depression hit Atlanta as hard as the rest of the country, and while the wealthy founding families of Inman Park held out, ensconced in their new Druid Hills or Ansley Park homes, residents like those in Inman Park bore the brunt of the economic slump. Joel Hurt died in 1926, and the Hurt family eventually left Inman Park. Owners of the grand Victorian homes were forced to foreclose or divide their homes into multi-unit apartments in an attempt to garner more money. The tone of the neighborhood swiftly slipped through the 1930s, and by the end of World War II, the housing shortage resulted in the transformation of the large, stately homes into boarding houses and apartment units. The Victorian mansions of the 1890s began to lose their shine, and Inman Park's exclusivity waned.

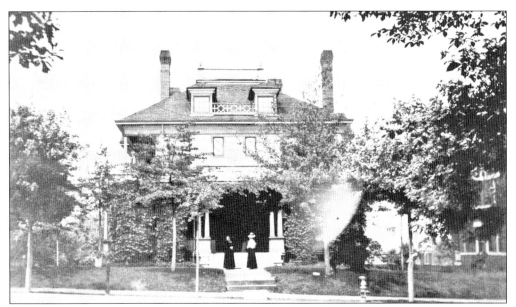

The house at 154 Hurt Street is shown here in its beginnings around 1900. Inman Park was at its peak when this photograph was taken, with all of Atlanta yearning to call it home. The house was designed by architect Walter T. Downing, who is credited with several other houses in the neighborhood. (IPNA Archives.)

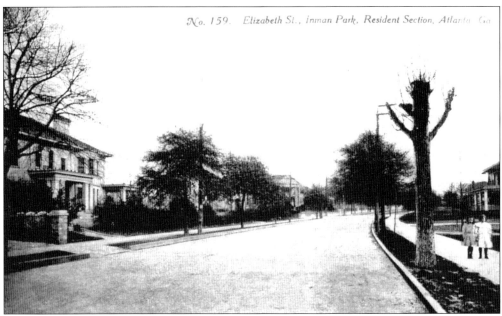

Charming in its realistic portrayal of Inman Park's premier street, this 1905 postcard shows Joel Hurt's Italianate mansion to the left with Asa Candler's Beaux Arts classic beauty in the background. The two little girls are passing by a tree that has seen better days. (Betty Ridderhoff.)

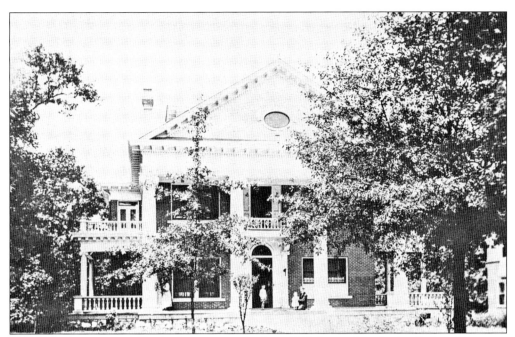

When this house at 116 Elizabeth Street was built in 1908 for produce broker Robert Cameron, it resembled Callan Castle with its Beaux Arts wings on either side of the main portion of the house. Today its style is more accurately described as Greek Revival; the side porches deteriorated during Inman Park's decline. (IPNA Archives.)

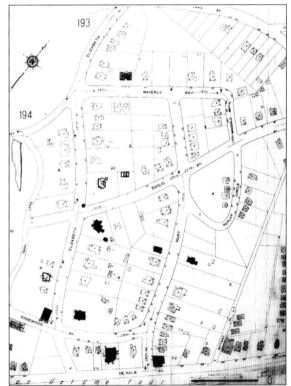

Footprints of the houses can be seen in this 1911 Sanborn Fire Insurance map. All of Atlanta's streets were drawn at the time to document the city's structures, and this view captures the east side of Inman Park. The majority of the houses on the map still exist. (Sharon and Craig Jones.)

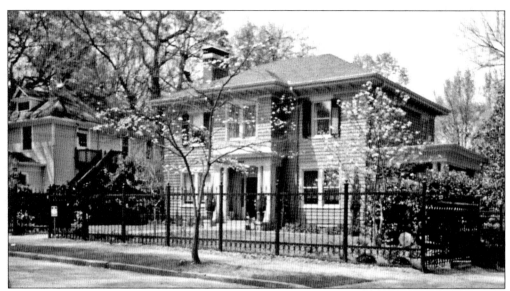

Adeline "Lina" Andrews Rauschenberg, seen here in about 1900, lived in several Inman Park homes. She was named after Atlanta pioneer and Inman Park Methodist founder Sarah Adeline Seitz, who lived with Lina's parents at 934 Waverly Way for decades after her husband's death. Seitz was not related to the Andrews but was a close family friend. Records indicate the Andrews family lived on Elizabeth Street when Lina was very young. Christian Rauschenberg built the house shown above at 940 Waverly Way for his wife, Lina, next door to her parents' house in 1922. Former Atlanta mayor Bill Campbell also lived in this house during his two terms as mayor from 1994 until 2002. (Above, courtesy of Sharon and Craig Jones; left, courtesy of the Inman Park United Methodist Church Archives.)

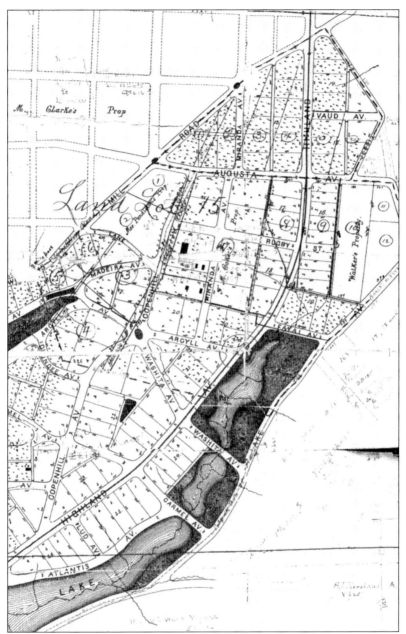

This 1887 map shows Copenhill Park, another elite suburb that was developed concurrently with adjacent Inman Park, most of which was originally part of Augustus Hurt's antebellum plantation. Copenhill sat on a high point overlooking the city of Atlanta and had two ponds that offered much in the way of health and entertainment to its residents. A large, fragmented lake extended throughout the southern portion of Copenhill. The lake and fringe park surrounding it took up most of the land between Highland and Lake Avenues where it crossed Carmel Avenue and the present-day Freedom Park. By 1889, the lake had been drained and had diminished, with a mere portion remaining in the northern end. This was the lake for which Lake Avenue was named, extending from what is today Sinclair Avenue to Krog Street. Copenhill Park is now part of the Inman Park Historic District. (Kenan Research Center at the Atlanta History Center.)

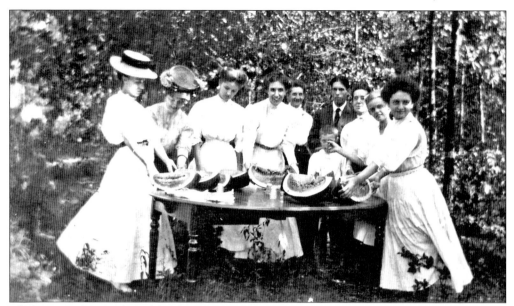

The house at 503 North Highland Avenue was built in 1907 and was part of the original Copenhill Park plat. This photograph, taken around 1915 in the backyard, depicts the Keheley family as they enjoy a watermelon feast. The house was rented by Marion and Sadie Keheley from about 1913 until 1927. They had two children: William and Elizabeth. (Sharon and Craig Jones.)

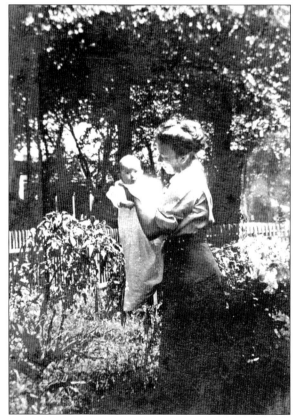

Sadie Keheley poses here with her newborn daughter in the backyard of 503 North Highland Avenue in 1914. The house had a series of owners throughout the 20th century and was divided into a duplex, which was typical of Inman Park and Copenhill Park houses. In 2007, the house was renovated and returned to a single-family dwelling. (Sharon and Craig Jones.)

Atlanta real estate mogul George W. Adair advertised a land auction of residential lots developed by the Copenhill Land Company in the *Atlanta Journal* on April 8, 1890. It is believed that "Copenhill" is a coined name from early investors Coker, Pennington and Hill. Charles Boeckh, a Hungarian immigrant and topical engineer, was the landscape architect of Copenhill Park as well as Grant Park, where Zoo Atlanta and the Cyclorama are located today. Like Inman Park, Copenhill offered its residents the benefit of regular streetcar service on the Nine Mile Circle. This streetcar circuit was built within a year of Hurt's Atlanta and Edgewood Street Railway Company's streetcar run to Inman Park. Although the two neighborhoods competed for residents, Inman Park and Copenhill Park held each other in high esteem. Some of the other mini-developments that sprang up adjacent to Inman Park were not so favored. (Sharon and Craig Jones.)

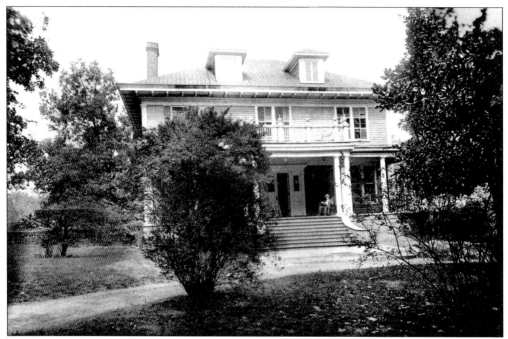

Seven Oaks, the home of Col. Peyton Harrison Snook, was located at 1202 Cleburne Avenue at the northwestern corner of Cleburne and Seminole Avenues. It is most likely Snook himself who is shown here rocking on the front porch around 1915. The house was later demolished and has been replaced by condominiums. (IPNA Archives.)

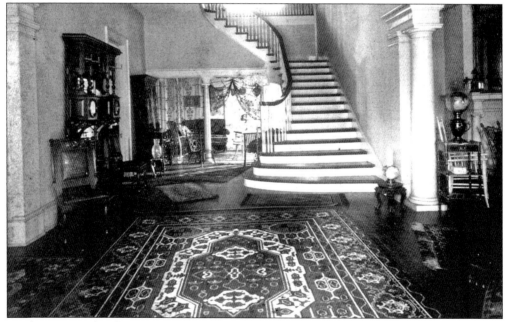

Inside Seven Oaks, the foyer reflects the refined taste of the time. Snook was in the furniture business and, at one time, he opened a furniture store with J. J. Haverty and Amos Rhodes. Their names are easily recognizable to furniture buyers today as founders of Rhodes Furniture and Haverty's Furniture Companies. (IPNA Archives.)

Gladys Hanson was a famous Broadway actress of her time and was the daughter of Col. Peyton H. Snook . She returned to Seven Oaks throughout her life and married Charles Cook there on April 12, 1916. This photograph shows her acting in *The Ware Case* in 1915. (IPNA Archives.)

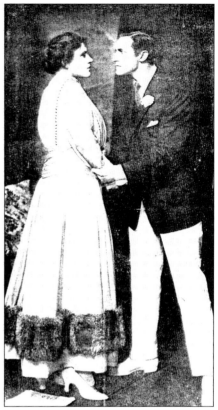

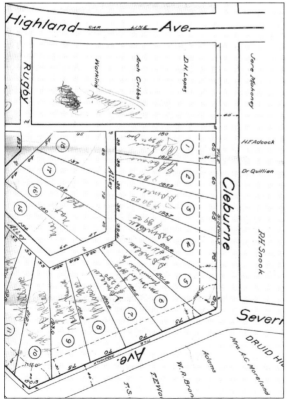

This 1909 map of the northeastern arm of Inman Park shows today's Seminole Avenue, Cleburne Avenue, and North Highland Avenue. Rugby Street still exists, although it remains unpaved and used only for alley access. Col. Peyton H. Snook's property can be seen here, among others, and someone penciled in the buyers after a land lot auction. (Sharon and Craig Jones.)

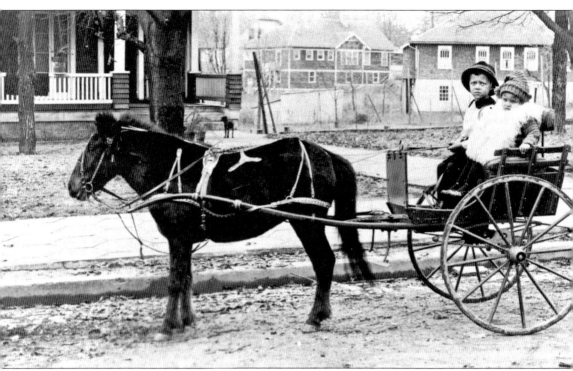

The Twitty family children are posed here in front of 484 Sinclair Avenue in 1916. In 1912, the house was built as a duplex by a brother and sister investor duo. While many houses eventually turned multi-family during the neighborhood's decline, an original duplex was uncommon. From 1912 to 1946, the house held more than 100 tenants, some of whom rented out the basement. For many years, the upper-floor portion of the house was occupied by two spinster sisters, one of whom rarely left the house and lowered a basket every day to retrieve her mail. Today the house has been fully restored and has taken the opposite course of many Inman Park houses: it has been changed to a single-family residence and beautifully so, with many original features still intact. Cleburne Avenue houses can be seen here in the background. (Kenan Research Center at the Atlanta History Center.)

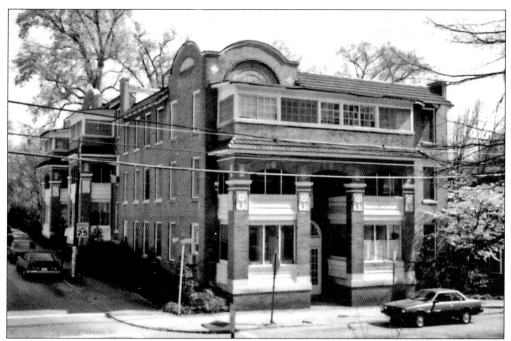

The apartment building at 461 North Highland Avenue is a common old Atlanta style. Its solid construction with a Mediterranean influence marks the building date as before the Second World War. This photograph was taken in 1990. In the 1880s, the building would have been lakefront property, as a series of lakes existed along North Highland Avenue from Colquitt to Elizabeth Avenues. (IPNA Archives.)

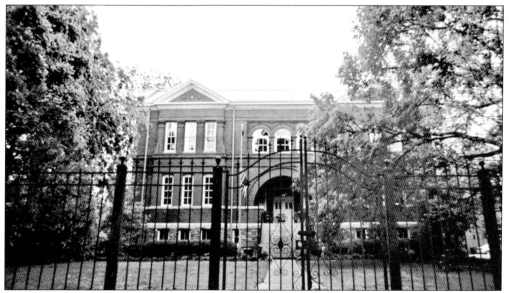

In 1892, the Atlanta public school system built this schoolhouse at 729 Edgewood Avenue. It was designed by renowned architect Gottfried L. Norrman. Originally it was called the Edgewood School and was later changed to the Inman Park School. Generations of Inman Park children attended here. Early attendees walked to the school, returned home for lunch, and then walked back for afternoon classes. (Sharon and Craig Jones.)

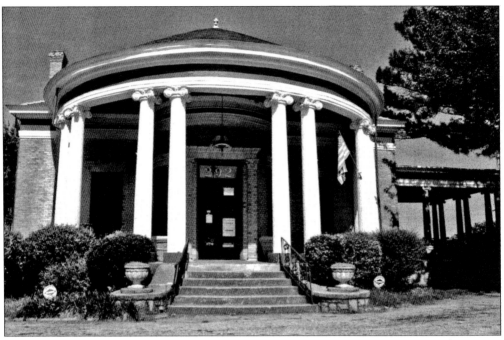

Designated by Atlanta in 1990 with Landmark Building Exterior status, the Kriegshaber House was built in 1900 at 292 Moreland Avenue with Willis F. Denny II as the architect. Victor Kriegshaber owned a building supply company and was a civic-minded and beloved resident of Atlanta. An architectural antiques store operated there in recent years; the house is still called by the store's name: the Wrecking Bar. (Inman Park Properties, Inc.)

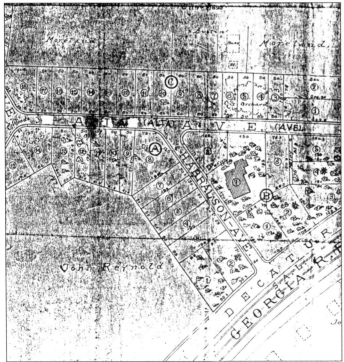

This 1895 map shows the division of the residence property of Madison Harralson, which was called the Oaks and contained a large house and an orchard upon the grounds. To the north, some of Col. Asbury F. Moreland's property and the Austin house that was built in 1892 can be seen. (Sharon and Craig Jones.)

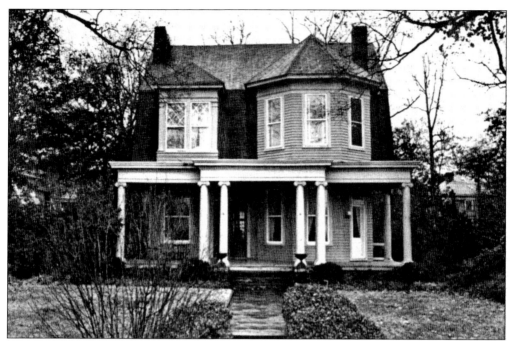

This house is located in one of the many mini-developments that comprise today's Inman Park Historic District: Moreland Park. Located at 1139 Austin Avenue, the house was built in 1899. Its style is eclectic, with Dutch Colonial–style features and classical accents. The photograph was taken in 1980. (Pat and Wayne Smith.)

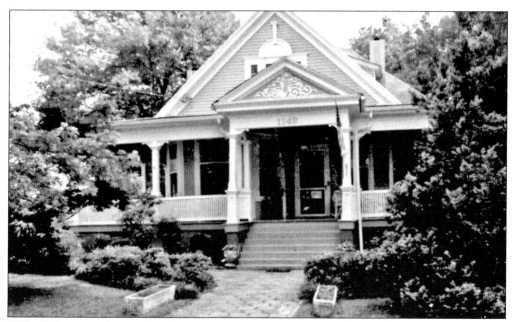

Willis F. Denny II designed this house, which is located at 1149 Austin Avenue on property once owned by his father-in-law and developed into Moreland Park. The house was built in 1896 for J. Moreland Speer, who was treasurer of the State of Georgia. Speer's initials are etched upon the front door's glass. (Pat and Wayne Smith.)

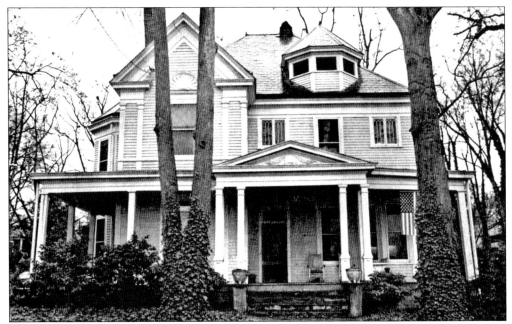

The house at 1131 Austin Avenue was also designed by Willis F. Denny II. This house was built in 1898 for Bloomer and Harriet Austin to replace an 1892 house and stable built on the same location. It is believed that today's Austin Avenue was originally the driveway to this home. The house is shown here in 1980. (Pat and Wayne Smith.)

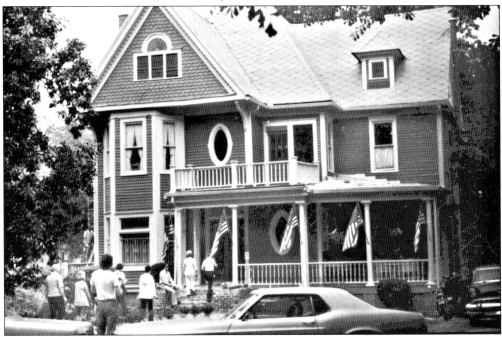

Various styles of Victorian architecture were built in Inman Park. This Eastlake-style house at 944 Euclid Avenue was built in 1896 and is shown here in 1977 during a festival home tour. At one time, the house was converted into a five-unit boardinghouse and had been condemned. (IPNA Archives.)

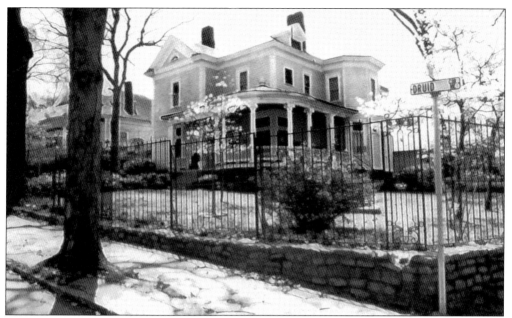

The southwest corner of Druid Circle and Dixie Avenue hosts this two-story house, pictured about 1975. The house is fully renovated today. Original plat maps of Inman Park show a spring located at the apex of Druid Circle's horseshoe-like shape; a house now shelters the small trickle of spring water. (IPNA Archives.)

Photographed around 1900, this house is believed to have been located at the western corner of Edgewood Avenue and Delta Place. It no longer exists, and no records verify its ownership. Its location would have been superb, with Delta Park to the east and Triangle Park to the north. (Pat and Wayne Smith.)

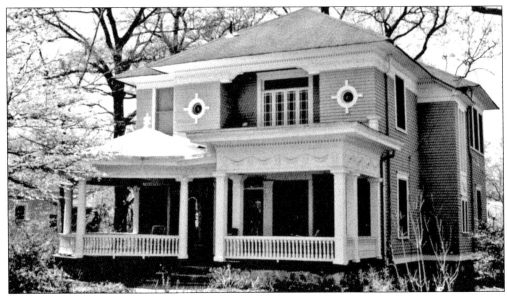

This house, photographed in 1980, graces the corner of Spruce Street and Dixie Avenue at 88 Spruce Street. A daughter of one of Atlanta's favorite authors, Celestine Sibley, lived here in the 1970s. This part of Inman Park was not part of the antebellum Hurt family holdings. (Pat and Wayne Smith.)

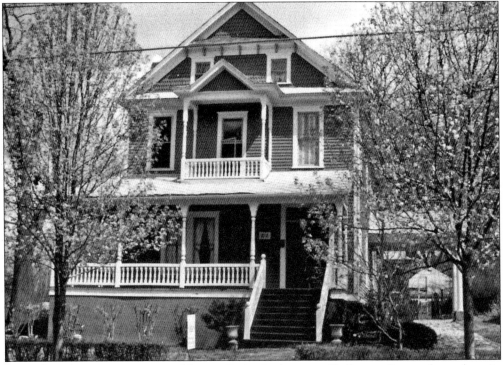

Located in the western portion of Inman Park, the house at 81 Spruce Street, shown here in 1980, was built around 1895. The Inman Park Historic District is bounded by Krog Street on the west, the east line of the MARTA tracks on the south, North Highland Avenue on the north, and Moreland Avenue on the east. (Pat and Wayne Smith.)

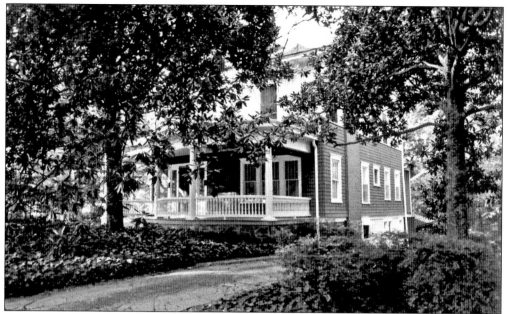

The house at 124 Elizabeth Street was built in 1907 and fronts the southern end of Springvale Park. Its original servants' quarters still exist behind the house on the edge of the park; most of such quarters in the neighborhood have been destroyed. The Brannon family owned the house for 80 years. (Pat and Wayne Smith.)

This house at 956 Waverly Way was built in 1905 and has an expansive lot. Originally the grounds contained tennis courts, a spring house, a carriage house, and a large rose garden. The house is pictured here almost 30 years ago, but its classic appearance has not changed. (Pat and Wayne Smith.)

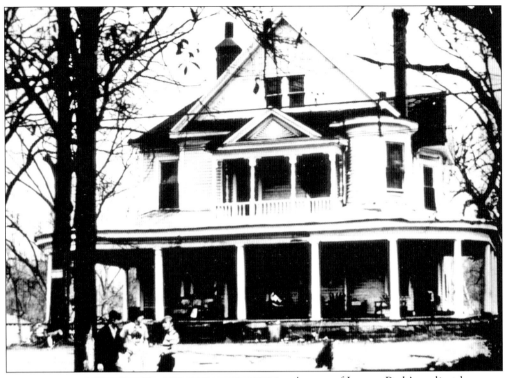

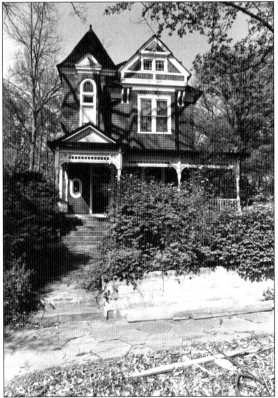

As one of Inman Park's earliest houses, 185 Elizabeth Street was built in 1896 by the widow of Dr. Daniel O'Keefe, surgeon general for the Confederate army in Atlanta. Reportedly Samuel Dobbs, Asa Candler's nephew who was president of the Coca-Cola Company from 1919 to 1922, lived in this house in the early 1900s. The house appears here around 1960. (IPNA Archives.)

Built around 1895 and seen here 100 years later, the house at 105 Druid Circle was occupied in its early years by Anna Maria Dayton Hale, who died here in 1898. She was the mother of William, Dayton, and Moses Hale, Atlanta businessmen for whom Hale Street in Inman Park is named. (IPNA Archives.)

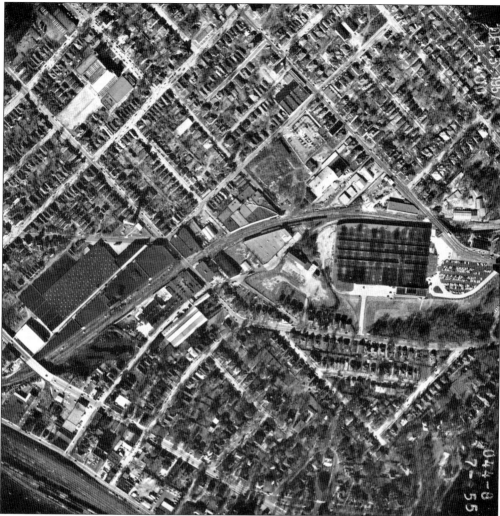

This aerial view of the western portion of Inman Park was taken in 1955 by the State of Georgia when it surveyed for the highway it planned to build through the middle of Inman Park. The large building to the right (east) is the Mead paper plant, a 21-acre site that closed in 2001; now the area is filled with an attractive mixed-use development called Inman Park Village. Just south of the Mead factory is the mini-development by Hale Investment Company that has marked its triangular pattern upon the landscape since its inception in the late 1880s by the Martin brothers, who sold it to the Hale brothers for final development. The Atlanta Stove Works can be seen to the left in the photograph; it has since been made into an office building containing restaurants and loft-type offices. (Georgia Department of Transportation.)

FOR SALE!

The Georgia State Lottery Property.

25 VERY VALUABLE LOTS. 25

Tuesday, December 1st, 1891, on the Premises.

AT 10 O'CLOCK.

This includes some of the most valuable and desirable property in Atlanta—right in the very heart of the city. Four storehouse & lots front opposite the postoffice and opera house. When the new steel bridge is finished, on Forsyth street no real estate in Atlanta will be worth more per front foot than the property we now offer to the highest bidder. Now is a most opportune time to buy, for 'tis an admitted fact that Atlanta property enhances in value annually. The substantial brick building on the corner of Forsyth and Walton streets is yielding a handsome income at present. The 21 vacant lots in Inman park are shaded with beautiful native oaks. Just the place for a gentleman to make an elegant home.

Edgewood avenue runs due east from the center of the city to Inman park passing directly through 21 of these lots. On it is the most perfect system of electric cars to be found in the United States and one of the grandest drives in the city. More expensive and handsome buildings are to be seen on this beautiful thoroughfare than upon any line of street leading from the center of Atlanta. One building alone when completed is to cost a cool million dollars. You may never have so favorable an opportunity to buy such property as this. Then attend the sale and secure your family a first-class location on a high and healthful ridge where the surroundings are choice and the real estate will continue to embrace for years to come. Every lot will be sold to the highest bidder. Titles indisputable. Terms cash.

Remember that the Forsyth street lots are in the same block with the Seltzer stores that I sold to eager purchasers at fair prices in 1890, our oldest citizens paying the best prices and securing the lots.

Apply at my office, No. 20 Kimball house Pryor street, for plats or information.

H. L. WILSON, Real Estate Agent.

In 1867, a statewide lottery was formed to support Atlanta's Civil War orphans. The lottery trustees were war heroes. The lottery ended in 1877, but it had acquired land adjacent to Inman Park that was embroiled in litigation over taxes and assessments. The lawsuit was settled in 1891, and the property was platted for development and auctioned off to pay the creditors. Seen here is the plat map, along with the auction advertisement. Waddell Street was named after the lottery trustee, J. D. Waddell. Wallace Street was named after another lottery trustee named Alexander Wallace and was renamed Krog Street in 1892 after Frederick Krog, who was involved in Atlanta's railroads. The city bought one of the lots and built the Edgewood School in 1892. (Left, *Atlanta Journal*, November 17, 1891; below, Fulton County Deed Records.)

This stick-style house at 158 Hale Street was moved to this location in 1894, allegedly from Marietta Street. The stick style is identified by the "sticks" of flat board banding that are applied in geometric shapes to the exterior of the house. At least one other house in the Hale development was moved from another location. The photograph shown here was taken around 1975. (IPNA Archives.)

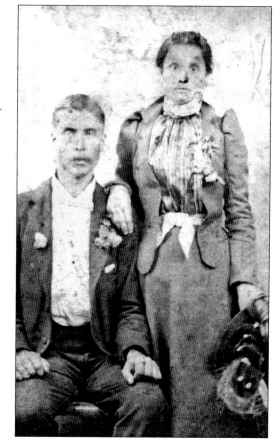

William and Minnie Spivey are shown here, probably in their wedding attire. They bought 802 Ashland Avenue in 1899, and the family lived in the small house for almost 70 years. William worked at the Atlanta Stove Works, conveniently located two streets over on Krog Street. (Spivey family collection.)

A birthday in 1955 was celebrated in the Hale development with a homemade cake and lots of laughter. While the mansions of Inman Park were starting to deteriorate and to be divided into apartments, life in the middle-class developments of the neighborhood adapted more easily. (Spivey family collection.)

$20.58

A MONTH

will buy a home adjoining Inman Park, on car line and twenty minutes schedule. Those having already bought are J. W. Adams, J. M. Brooks, J. A. Bridwell, Mrs. M. V. Coleman, Mrs. McIndon, W. C. Crumley, G. M. Bishop, J. W. Rose, S. W. Baxter, S. T. Gibson, T. J. Bishop, D. J. Anderson, A. K. Delay, G. W. Powell, A. R. Wright, J. M. Walker. Why pay more rent? Come to see us at once and own your own home.

HALE INVESTMENT CO.

apr20 fri sun

On April 20, 1894, the Hale Investment Company advertised its lower-income housing development in the *Atlanta Constitution*, capitalizing on Joel Hurt's successful Inman Park. Eastern Atlanta needed housing for all types of workers. (Sharon and Craig Jones.)

Joel Hurt platted a 20-foot reservation of green space between the Hale development and Inman Park in an effort to cultivate the exclusivity of the more expensive Inman Park. Interestingly he did not put such a buffer zone between Inman Park and Copenhill Park and many other adjoining developments. The Hale-Strickland development was platted in 1893. (Fulton County Deed Records.)

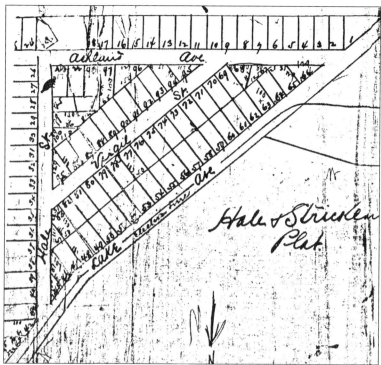

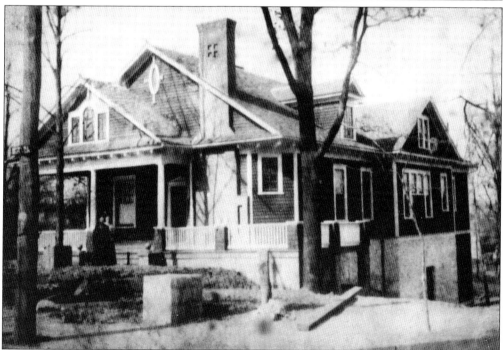

Construction at 840 Dixie Avenue had just finished when this photograph was taken in 1903, and debris appears in the foreground. Two women in their long dresses pose near the front steps. The house had a dumbwaiter in its early days, and later during Inman Park's decline, the house was divided into four apartments. It has since been fully renovated. (Lisa and Jerry Prine.)

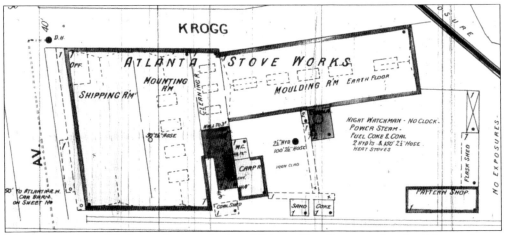

The Atlanta Stove Works was built in the late 1890s on Krog Street, and its facilities are drawn here in the 1911 Sanborn Fire Insurance map. Today the old factory is included in the Inman Park Historic District. Elite businesses and restaurants are located inside the building that once included a moulding room with an earth floor. (Sharon and Craig Jones.)

In 1950, little Judy Hicks poses outside her parents' house at 810 Virgil Street; the photographer's shadow is in the foreground. This street is an anomaly in the Inman Park Historic District as it is almost completely made up of shotgun houses. Many of the early inhabitants worked at the Atlanta Stove Works. (Judith Hicks Phillips.)

Three soldiers of the First World War stand outside 802 Ashland Avenue, with 810 Virgil Street behind them at right. The soldiers' names are unknown. Three million Americans served in this global war, fought primarily on European soil. This photograph was taken in about 1917. (Spivey family collection.)

Things were just as groovy on Ashland Avenue as they were in the rest of America in 1964. Behind this young man, Ashland Avenue runs to the west. Several of the folk Victorian houses can be seen. A woman hurries past 796 Ashland Avenue. Asbestos siding had made its debut by this time and thoroughly covered many of the houses of the era. (Spivey family collection.)

A 1942 Sunday school class at Inman Park Methodist Church is captured here busily working on a project most likely related to World War II. The Stone Mountain granite walls of the church seem to never change. The walls have sheltered Inman Park's community for more than a century. (Inman Park United Methodist Church Archives.)

Inman Park proudly supported its World War II soldiers. The newly wed Mr. and Mrs. Harry Smith Jr. are shown here. Sadly he died shortly after this photograph was taken in World War II. His parents lived on Elizabeth Street. The newlyweds lived on North Highland Avenue. (Inman Park United Methodist Church Archives.)

A TRIBUTE

TO

Caughey B. Culpepper, Jr.

BY

ELOISE HENRY

ON BEHALF OF

THE YOUNG PEOPLE OF INMAN PARK

In this twilight hour of the Sabbath Day we have come to pay tribute to the memory of a young man who spent his youth preparing to live abundantly and who died as gloriously as he had lived. Because of his death, there is a space in our midst that cannot be filled. There is a void in our hearts that cannot be removed. There is a laugh that cannot be duplicated.

For Caughey Culpepper, Jr., from earliest childhood, was a favorite with old and young in the community, in school, and in the church. As he grew in stature, he, like Jesus, grew also in wisdom. He was a student, a scholar. With a definite goal in mind, he applied himself to the task at hand, devoting all of his efforts to doing a good job day by day. The culmination of his educational career came in the awarding of his L.L.B. degree by Emory University in '43. He shared with others the benefits of his training and demonstrated his oratorical abilities in his speeches and debates our own Young Peoples Department.

Like Jesus also, Caughey was a worker. His hours before and after classes were spent in useful employment, and in first years at Emory, his friendly smile and helpfulness were known to children and grownups as he worked in the Inman rk Library.

Not only was he always present at meetings and get-togethers, but he lent a hand, whether it was to preside, or whether was to help paint the floors of the Young Peoples Department, write a column for the IPYIP paper, or carry the Thanksving basket. He laughed longest when we played the laughing game, and his car was never too full nor his time too limited take some of the young people home after the party.

His boundless energy, his adaptability, and his spiritual stature made him a natural leader. Serving in many capaci-s in a number of church, school, and fraternal organizations, he always championed the good and true and was progres-e in his thinking. His thoughtfulness, courtesy, and generosity endeared him to all.

There is a loss to our lives that cannot be measured. There is a place in our hearts that no one else will fill. But re is an inspiration and a challenge that comes from the knowledge that Caughey's life was spent preparing to live as a e son of God and that he died for the things that he felt made life worth living.

MAN PARK METHODIST CHURCH
lanta, Georgia
ptember 10th, 1944.

The Second World War claimed the lives of more than 72 million people with 400,000 American casualties, making this war the most deadly in world history. Inman Park was not without its losses. The community suffered deaths of its young people, and one in particular is memorialized here. "A Tribute to Caughey B. Culpepper Jr." is a heartfelt eulogy written by one of Culpepper's young friends at Inman Park Methodist Church. Culpepper lived at 926 Waverly Way and was "a favorite of old and young in the community, in school and in the church." This tribute individualizes the loss of so many of America's youth as the details of Culpepper's life are described. Just before he died, he had received a degree from Emory University, and it seems fitting that he is memorialized by the church family that founded the college. (Inman Park United Methodist Church Archives.)

This house at the corner of Edgewood Avenue and Spruce Street at 804 Edgewood Avenue was built around 1890. By the 1940s, it had been divided into 13 apartments. The house provided a stable, middle-class home to many families during that time. The Bowers family is seen here in 1944 on the Spruce Street side of the house. (Mrs. Joseph Edward Bowers.)

On the front lawn of 804 Edgewood Avenue sits Michael Bowers (baby at left), former Georgia attorney general, and his cousin in about 1944. Both Bowers families lived in apartments in the house for years. It is said that as boys, they found a tin box of Confederate money buried under the house, which most likely was placed there before the house was built. (Mrs. Joseph Edward Bowers.)

The apartment house at 804 Edgewood Avenue provided a home for this little girl, seen in 1948, and many families. Originally built by Thomas W. Latham in 1890, this beautiful Queen Anne–style home was one of the earliest in Inman Park. Seen in the background is 814 Edgewood Avenue, the Winship house. (Mrs. Joseph Edward Bowers.)

A view from the Spruce Street side of 804 Edgewood Avenue can be seen here in 1948. The houses behind the children are, from left to right, 56 Spruce Street (formerly 790 Edgewood Avenue), 62 Spruce Street, and 66 Spruce Street. Bishop Warren A. Candler made his second Inman Park home at 790 Edgewood Avenue. (Mrs. Joseph Edward Bowers.)

Local businesses advertised in a 1930s cookbook prepared by the Inman Park Methodist Church, which harks back to the days when Inman Park residents could shop for groceries at stores located mere feet from their homes. Telephone numbers were listed here as either "Ivy" or "Hemlock." The Hurt Street Pharmacy was located where restaurants are now. Many of Inman Park's streets still have brick store buildings that at one time were commercial. Today there has been a resurgence of local commercial enterprise. Businesses are finding their way back to the neighborhood, and residents enjoy stores, restaurants, dry cleaners, and pet grooming businesses, located only a short walk from their front doorsteps. The active neighborhood association guards the peaceful ambiance of Inman Park by enforcing city regulations of liquor licenses and parking for automobiles. (Inman Park United Methodist Church Archives.)

The trolley tracks are long gone in this 1951 photograph of Edgewood Avenue at Elizabeth Street, looking west. Automobiles have taken the streetcars' place in Atlanta transportation, and a gas station can be seen on the right. Today other businesses are housed at the corner of Edgewood Avenue and Elizabeth Street where the gas station once was. (Special Collections and Archives, Georgia State University Library.)

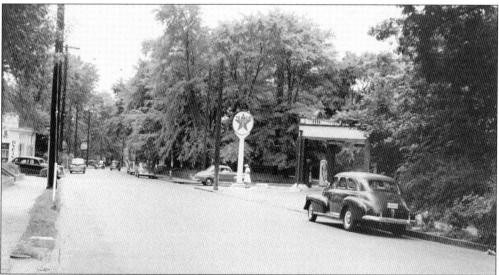

North Highland Avenue winds its way south through Copenhill Park, which is now part of the Inman Park Historic District, in this 1950s photograph. On the corner of Cleburne Avenue, another gas station was located; that land is now part of Freedom Park. (Special Collections and Archives, Georgia State University Library.)

FOSTER BROS.

A good Barber Shop for men, women and children. We do Dry Cleaning and Pressing. Monthly membership $1.50 for eight suits, or four suits for $1.00. Called for and delivered.

354 Euclid Avenue—At Little Five Points

INMAN PARK

Phone IVy 7462

This advertisement for Foster Brothers Barber Shop was taken from the 1924 Inman Park Methodist Church directory. The Little Five Points business district was starting to grow and had established its nickname. Apparently Inman Park residents could get their hair cut and their clothes pressed at the same time when they patronized this business. (Inman Park United Methodist Church Archives.)

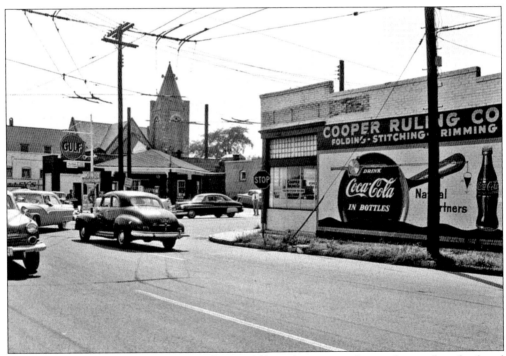

Coca-Cola Company founder Asa Candler would have been amazed to see his product displayed on the side of a building with automobiles whizzing by in this 1957 photograph. The Inman Park Methodist Church can be seen in the background, and yet another gas station is on the corner where longtime Atlanta restaurant Son's Place is located today. (Special Collections and Archives, Georgia State University Library.)

Five

RISEN FROM THE ASHES

In the 1950s, Inman Park plunged into a state of danger and dilapidation, inhabited by residents that lacked interest in maintaining the architectural and natural beauty of the neighborhood. Homes went from bad to worse; yards and public park space, so carefully designed by Joel Hurt, went untended. Gunshots, litter, illegal drug activity, prostitution, and stray dogs were the new associations of this once-elegant district.

The City of Atlanta, deeming the neighborhood untenable, rezoned Inman Park and agreed to plans to demolish the neighborhood in favor of a 12-lane expressway. In 1961, the Georgia Department of Transportation began purchasing Inman Park properties along the proposed road. The individual outcries of the few remaining home-owning residents were not sufficient to halt the demolition that swiftly ensued after the DOT bought the properties. The loudest of opposition in the 1960s was Judge Durwood T. Pye, a Fulton County Superior Court judge, whose 1904 home stood proudly amid the demolished remains of his neighbors' homes on Poplar Circle.

On a dreary November day in 1969, an antiques appraiser named Robert Griggs drove into Inman Park en route to the home of Judge Pye. His mission: to assess the value of the house's stained-glass windows before demolition. As he drove down Euclid Avenue, he passed a stunning Victorian home, the Beath-Dickey home, which he knew immediately he must purchase. Despite the 34 tenants who were living in the house at that time and warnings from friends and financial advisors, Griggs bought the home for $22,000 and poured himself into the renovation of this gem.

Following in Grigg's footsteps came the determined urban pioneers of the 1970s and 1980s, willing to take on the dangers, hard labor, and expense to rebuild Inman Park. They renovated the houses, structured the first neighborhood association, organized the annual Inman Park Festival, created a monthly newsletter, renovated the parks by organizing the Hurt Planters, and founded a preschool for their children. With persistence and progressive spirit, Inman Park truly emerged as a phoenix from its ashes, soaring gloriously with the butterfly leading the way.

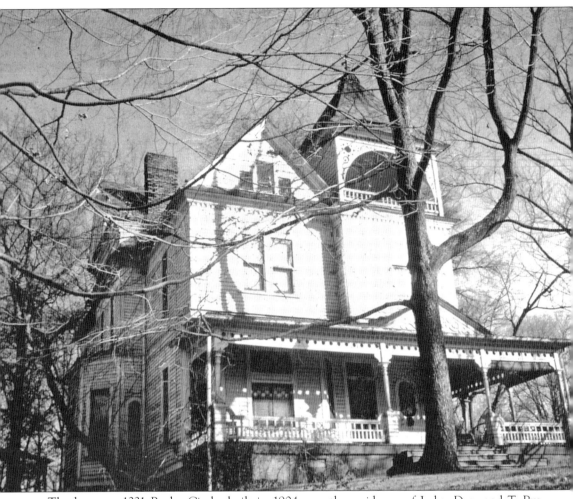

The home at 1221 Poplar Circle, built in 1904, was the residence of Judge Durwood T. Pye, a Fulton County Superior Court judge who purchased this house in June 1943. Six months later, Judge Pye married Quinney Fort, and the newlyweds moved into their home July Fourth weekend, 1944. The judge and other Poplar Circle residents made a pact not to sell their homes, but one by one, homeowners were coerced by the state. Judge Pye held out in his legendary legal battle until the Georgia Department of Transportation evicted the Pyes in 1970. Quinney Pye died the following October, and the judge believed the trauma of the eviction was a major factor in her early passing. In 1969, Robert Griggs was on the way to appraise Judge Pye's stained-glass windows when he saw the Beath-Dickey house. He bought it shortly thereafter and began Inman Park's revitalization. Judge Pye's home was destroyed after this photograph was taken in 1972. (Cathy and Bo Bradshaw.)

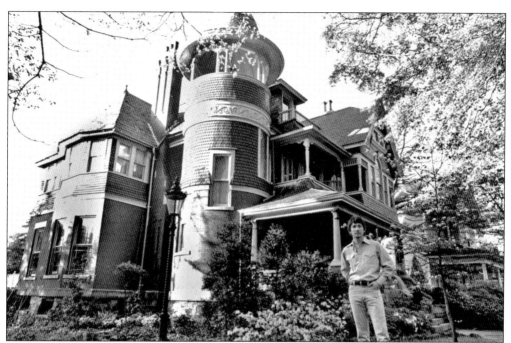

Robert Griggs stands in front of the Beath-Dickey-Griggs house at 866 Euclid Avenue about 1980. The lamppost is original, as are the pink marble porch columns. The turret is a "belvedere," meaning "beautiful view" in Italian, because its sides are open. It would have originally looked out upon the Mesa across the street, which was an open space in Joel Hurt's 1889 plans. (IPNA Archives.)

Atop the belvedere is one of the unique ornamental details of the Beath-Dickey-Griggs house, captured here in 1975. Several of the original gas lights, inside and out, still work. The parlor fireplace tiles depict native Georgian flora and fauna, such as Cherokee roses and thrasher birds. (IPNA Archives.)

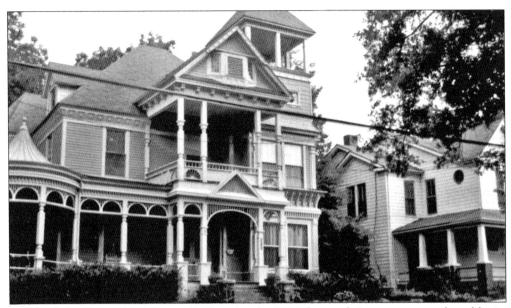

First built for the wealthy George E. King family, 889 Edgewood Avenue was purchased by its third owner in 1955 and turned into a boardinghouse. A fire halted that unseemly role, and it was left to its demise until it was bought by a fourth owner and renovated in 1976 as shown here. The Glenn house next door is unrecognizable as a Grand Dame of the 1890s. (Pat and Wayne Smith.)

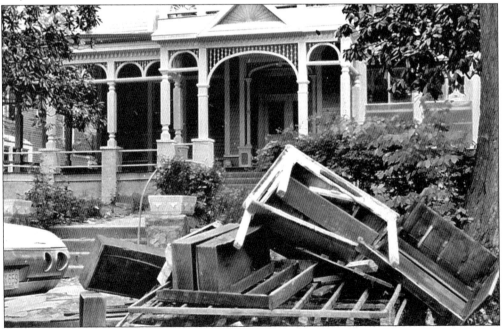

The house at 889 Edgewood embarks upon renovations in 1977 under the careful hand of its fourth owners, with the ensuing mess that results from restoration. The boardinghouse years had been rough on the old mansion, and making the house livable was a feat; there was a payphone on the front porch, and rumor has it that the lost-and-found had more than one pair of false teeth. (IPNA Archives.)

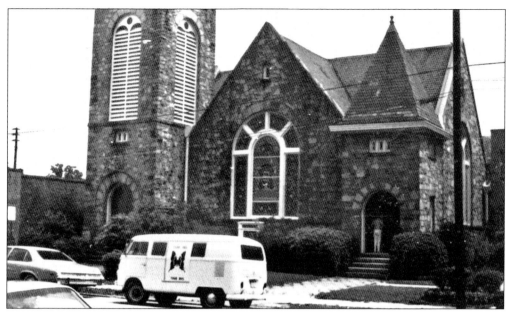

The Inman Park Methodist Church appears here in 1977 looking unchanged since its construction in 1898. It is said that the church's first benefactor, Asa G. Candler, stood in the doorway every Sunday morning and tapped the heads of the children as they entered to make sure they were reminded of the seriousness of their religious education. (IPNA Archives.)

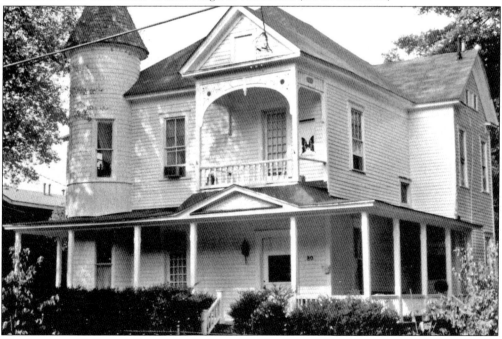

The house at 80 Spruce Street was built in 1888 by Samuel D. Niles, who was believed to be Joel Hurt's building contractor. Niles fell down the stairs to his death, and it is rumored he still haunts the stairwell. In the 1960s, the house was divided into six apartments, became a bordello, and the turret room was the scene of a murder. The house has been beautifully restored. (Pat and Wayne Smith.)

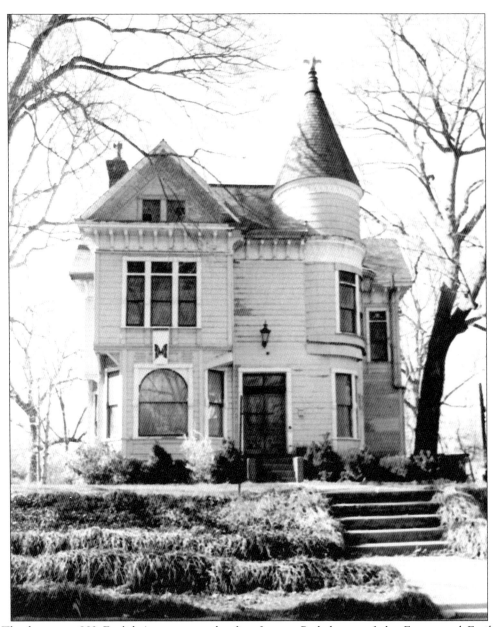

The house at 882 Euclid Avenue was the first Inman Park home of the Ernest and Emily Woodruff family, and they resided there for approximately 10 years. It is pictured here in 1977, nearly six years after urban pioneers began their renovation efforts on this home. It was one of the first homes to be purchased during Inman Park's renewal. As a neighborhood favorite, it has been included in the annual Inman Park Tour of Homes, which first originated on December 20, 1970. The original purpose of the tour of homes was to draw attention to the transformation of Inman Park amid encroaching city demolition, with hopes of bringing new pioneers and financing to the resurging community. Even without its front porch, the dignity of the Norrman-designed Victorian is apparent. Today the porch has been restored, and it is said that the cost of the modern porch construction was more than the original construction costs of the entire house. (IPNA Archives.)

The corner of Elizabeth Street and Waverly Way is seen here in 1977. Restoration pioneers discovered that rats accompanied neglect of historic properties and launched *Hot Rats*, a newsletter offering restoration advice, announcements, and updates on issues of interest to the neighborhood. Renamed the *Inman Park Advocator*, the newsletter continues as the main source of information on progress and updates relevant to Inman Park. (IPNA Archives.)

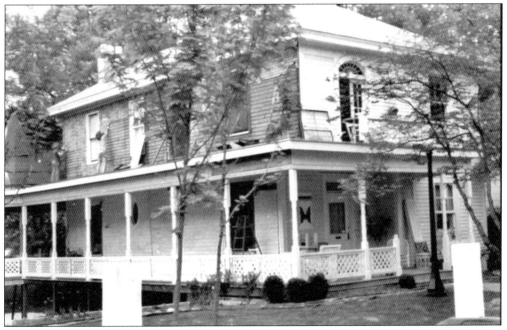

The 1970s were a time of restoration for 766 Dixie Avenue, which was built in 1905. Typically a house was made livable on the inside before exterior renovations were completed. The butterfly banner was created to be a signal that serious restoration was going on inside—even if that was not apparent from the outside of the house. (IPNA Archives.)

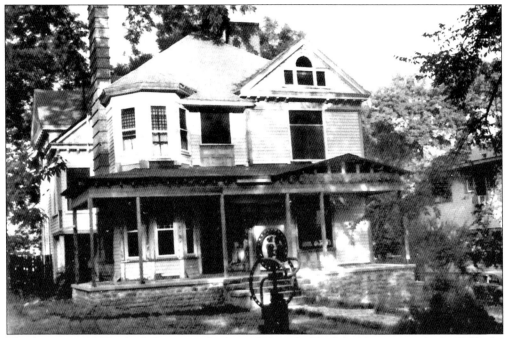

This house at 220 Elizabeth Street was built in 1893 in the Eastlake Victorian style. In 1980, the house was still undergoing some exterior restoration on the porch as seen here. The chimney is a one-of-a-kind in Inman Park. Today the house is fully restored, and the interesting artwork remains in the front yard. (Pat and Wayne Smith.)

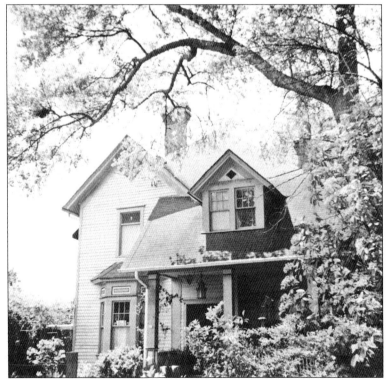

Asa Candler's sister, Florence Harris, lived in the Candler Cottage at 122 Hurt Street in the early part of the 20th century. In the 1970s, the house became famous as Ma Hull's Boarding House. Allegedly the clientele included students, politicians, and those curious visitors who had simply read about it in *Rolling Stone* magazine. The Candler Cottage was remodeled in the early 1980s. (Sharon and Craig Jones.)

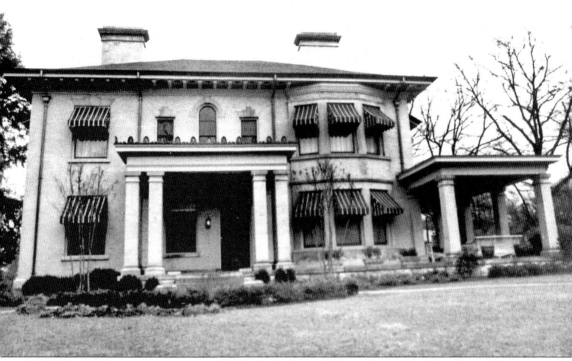

Joel Hurt's Italianate mansion at 167 Elizabeth Street had its share of neglect during Inman Park's years of decline. From Joel Hurt's death in 1926 until 1980, the house hosted two different nursing homes and a school, all while falling into further dilapidation. This photograph was taken in 1984 when restoration was underway. The house has been completely restored and appears almost as it did when the Hurts inhabited it. The original walls in the dining room were hand-painted in a popular late Victorian style, and they have been exactly reproduced. Miraculously the original built-in oak bench in the entrance hall remains without injury. Georgia now has tax incentive programs for homeowners who substantially rehabilitate historic houses. Currently the program allows homeowners who qualify to obtain a state income tax credit and an eight-year property tax assessment freeze. (IPNA Archives.)

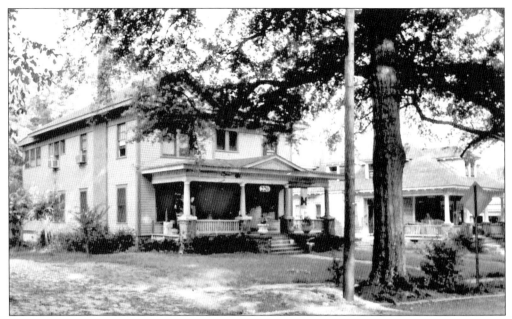

Seen here in 1980, the homes at 226 and 230 Elizabeth Street were both built in 1908 and have been completely restored. By 1973, 226 Elizabeth Street had been divided into seven apartments. 230 Elizabeth Street has only been restored in recent years. Both houses are a tribute to Inman Park. (Pat and Wayne Smith.)

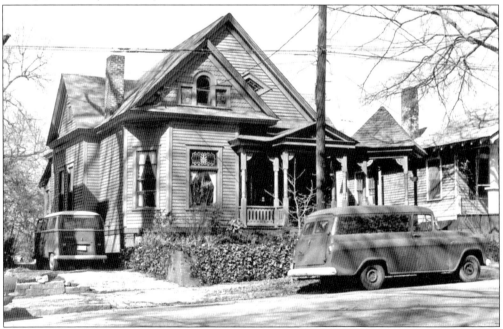

The house at 846 Ashland Avenue was built in the late 1880s, along with the house next door to the west, and it predates the Hale Investment Company development of 1893. Originally the triangle of streets was platted by Elijah and David Martin, who sold the land to the Hales. Local legend holds that this house once housed 38 vagrants and 48 gamecocks. Today the house is pristine. (IPNA Archives.)

The Hurt Planters work on a corner park at Ashland Avenue and Virgil Street in 1980. During the 1970s, a neighborhood effort to eradicate kudzu vines in Inman Park's green spaces was called the Kudzu Kaper; reportedly it was fueled by sweat and beer. Seen in the background is 829 Ashland Avenue, a folk Victorian. (IPNA Archives.)

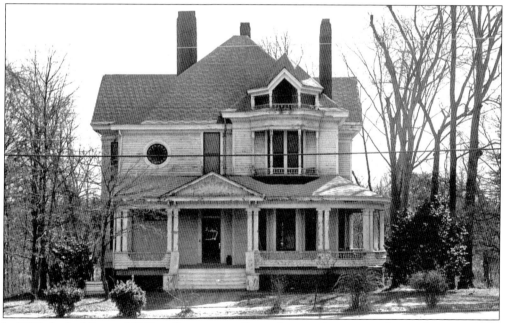

In 1975, the building at 146 Hurt Street was suffering from neglect, as seen here; it has since been restored. The houses on the southern half of Hurt Street now face an open park where Inman Park Baptist Church and the Poplar Circle homes once stood. A MARTA rapid rail station is also across the street on the corner of Hurt Street and Edgewood Avenue. (IPNA Archives.)

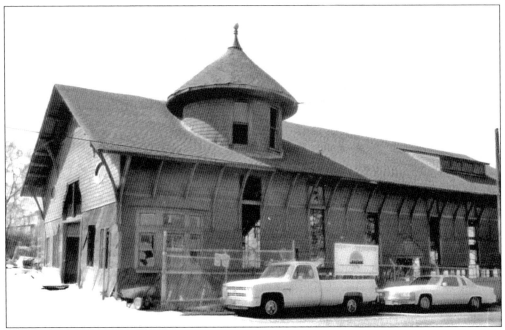

Restoration on the Trolley Barn is underway here in 1985. The Trolley Barn, also called the Car Shed, was built in 1889. Today it is owned by City of Atlanta and leased to a nonprofit group for $1 per year. It is primarily a reception hall and can be rented for special events. (IPNA Archives.)

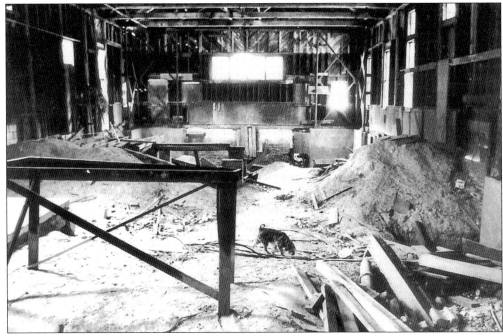

This photograph shows the interior of the Trolley Barn in 1977. Over the years, this building has been used as a Baptist church, basketball courts, a farmers' market, and the headquarters for a telephone cable construction firm before it was condemned in 1975. The gaping hole and earthen floors are now covered with hardwood flooring. (Pat and Wayne Smith.).

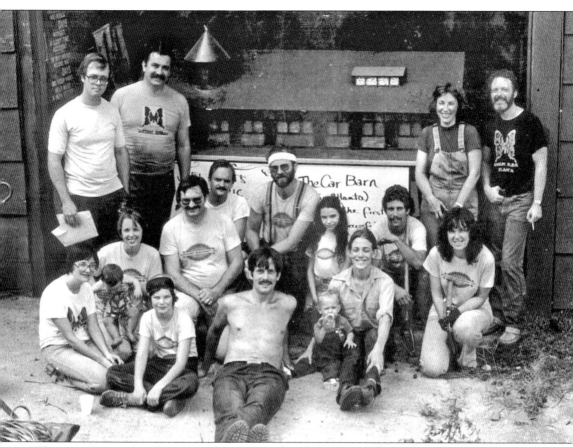

Urban pioneers at their finest pose here after a day of clean-up at the Trolley Barn in 1980. The young urban pioneers living in Inman Park in the 1970s and 1980s were bound together by idealism and diligence in transforming Inman Park. Exemplifying community pull at its best, the neighbors formed the nonprofit Atlanta and Edgewood Railway Company one year after the Trolley Barn was condemned in 1975 to oversee the renovations of the historic landmark. Inman Park Restoration, Inc., financially supported renovations until the city allocated about $640,000 of its federal Community Development Block Grants to the project. The tireless spirit, talent, and hard work of Inman Park residents rescued and preserved Inman Park's architecture. The shirtless man in the front row was the district's city council representative at the time. He still resides in Inman Park. (Pat and Wayne Smith.)

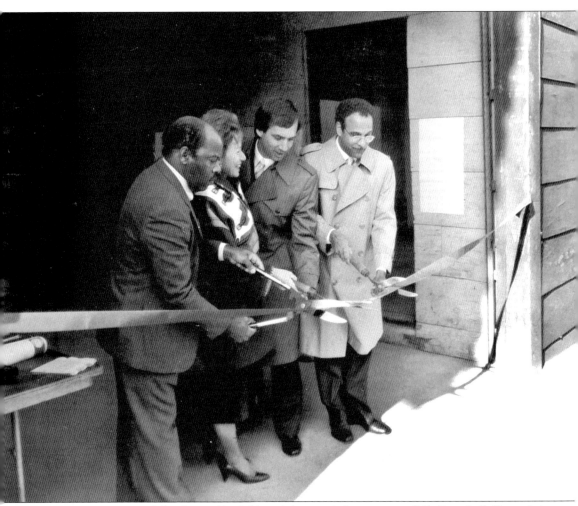

U.S. representative John Lewis (far left) and former Atlanta mayor Bill Campbell (far right) appear at the Trolley Barn for the ribbon-cutting ceremony in December 1985, celebrating the completion of the structure's extensive interior and exterior renovations. The shingle-style building first went into use in 1889 as a storage and maintenance facility for Joel Hurt's electric trolley company, the Atlanta and Edgewood Street Railway Company. However, its use was short-lived, as trolley lines consolidated and the technological advances of the automobile spilled over into the trolley industry. The fully restored building today appears exactly as it did in the 1890s, and Inman Park residents gather there for neighborhood parties, including the Tree Huggers Ball, which is a fund-raiser to support the neighborhood's ancient trees and the planting of new ones. The neighborhood archives are also housed in the building. (IPNA Archives.)

The house at 490 North Highland Avenue was destroyed, although it could have been saved and restored. It has since been replaced with a modern-style building, somewhat out of place in Inman Park's Victorian environment. This photograph was taken in 1999. (IPNA Archives.)

After this photograph was taken in 1990 of 479 North Highland Avenue, this early 1900s house was burned. Years later, the lot remains empty and overgrown. The loss of houses such as the ones on this page sparked the neighborhood to ask the City of Atlanta for historic designation. Infill housing is now strictly regulated to ensure the tone of the neighborhood is preserved. (IPNA Archives.)

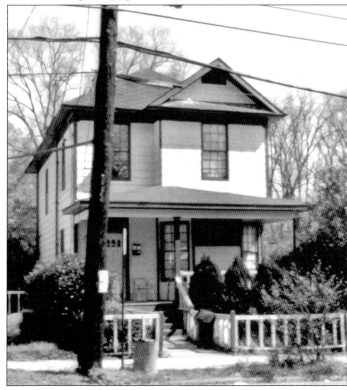

North Highland Avenue today reveals the remnants of former houses demolished by the state in the 1960s and 1970s in anticipation of building a major expressway through Inman Park: the broken masonry of an old chimney and mossy stones where a terrace or driveway once was. This photograph shows what the locals call the "stairs to nowhere," many of which still today mount only to the open space of Freedom Park. The park space was the result of negotiations between the city and its citizens during the period when the I-485 land was being resold and rezoned. Today the Freedom Park Conservancy is a volunteer neighborhood organization combining neighbors from eight old in-town neighborhoods that aims to protect the green space of Freedom Park. Consisting of more than 200 acres of land, Freedom Park is still a work in progress today. Seven works of art have been permanently installed throughout the park. (IPNA Archives.)

In the mid-1970s, the State of Georgia erased plans for the I-485 interstate highway and began to sell off much of the land it had acquired. The state retained 219 acres with the idea of building a new parkway in place of the originally planned highway. This land, once home to many Inman Park families, became overgrown with kudzu and further blemished Inman Park's landscape. (IPNA Archives.)

By agreement with the city, a small number of new homes such as these on Carmel Avenue today were rebuilt along the periphery of Freedom Park. The new houses were required to comply with stringent historic design standards. Walking and biking paths now stretch across the once-kudzu-covered hills. To the right is a ravine that was part of a lake in the 19th century. (Sharon and Craig Jones.)

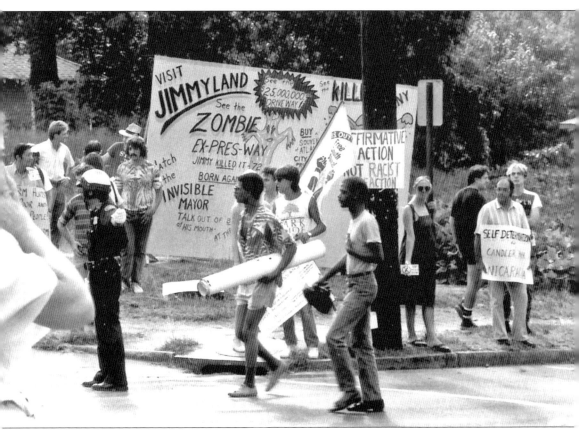

The "road fight" was a hard fought battle by Inman Park residents. Although the I-485 proposal had been deleted, a new controversy ensued. In 1981, Pres. Jimmy Carter announced his plan to build his presidential library and policy center on land near a proposed parkway—today's Freedom Parkway. Ground was broken on his $25-million library in 1984, fueling outright anger in the community. Protests by the "roadbusters," pictured here in 1985, were staged to express community sentiment opposing the planned expressway, nicknamed the "Ex-Pres-Way." Residents took every legal and political recourse to halt the city's Department of Transportation plans. In typical Inman Park fashion, neighbors organized CAUTION, Inc. (Citizens Against Unnecessary Thoroughfares in Older Neighborhoods), a group of nine neighborhood associations to protect their historic district from government encroachment. In the heat of protest, 50 people were arrested. (IPNA Archives.)

The "road fight," as it is recalled by many long-standing Inman Park residents, was the pinnacle of unifying endeavors. The civic and legal battle lasted for years and represents a true David-and-Goliath type challenge. Shown in this 1985 photograph, the young residents swung into action defending the neighborhood they were reclaiming. (IPNA Archives.)

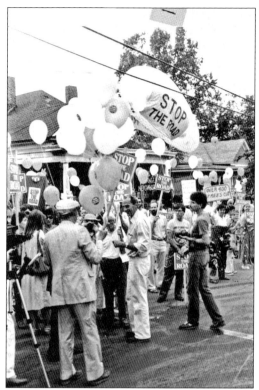

Former Atlanta mayor Maynard Jackson is flanked by Inman Park representatives holding festival posters in 1976. The building of the highway was highly politicized, and Inman Park residents worked diligently to gain city-wide recognition of the vitality and historic merit of their neighborhood. Note the signature Inman Park butterfly on the posters. (IPNA Archives.)

This photograph, looking east along Edgewood Avenue, shows the Inman Park Festival activity in April 1978. The bell tower of the Inman Park Methodist Church can be seen in the distance at left, and the then-condemned Trolley Barn is at right. The festival is completely organized by Inman Park residents and includes the beloved tour of homes. (Pat and Wayne Smith.)

This "Smalltown Downtown" logo was the theme of the 1977 Inman Park Festival. Inman Park residents prided themselves on their commitment to sustaining a small-town lifestyle amid their dedication to inner-city growth. The theme is as apt today as it was more than 30 years ago. (IPNA Archives and Pat and Wayne Smith.)

The butterfly is ubiquitous among Inman Park residents. This 1977 festival scene shows the display of butterfly items available for purchase. Spirited Inman Parkers are proud to show their butterfly spirit on t-shirts, flags, and signage. Seeing the butterfly emblem galvanized early residents, reminding them of the transformation at hand and of the rich heritage they were preserving. (IPNA Archives.)

The Inman Park Festival Parade is easily the most intriguing in Atlanta. Led by the Inman Park butterfly, the parade rolls down Edgewood Avenue each year, entertaining thousands of spectators with marching bands, floats, politicians, drill teams, mascots, clowns, jugglers, and much more. Shown here, three young ladies march in the 1978 parade. (Pat and Wayne Smith.)

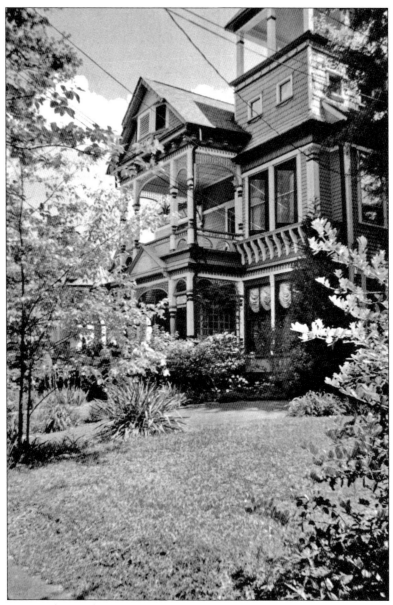

The house at 889 Edgewood Avenue is now the King-Keith House Bed and Breakfast. Boasting 13 exterior colors on her facade, this "painted lady" has been renovated to original glory and is one of the best known homes in Inman Park. Serving also as the meeting spot for historic walking tours, the King-Keith house welcomes visitors with open arms. Three other homes have become bed-and-breakfasts as well. Sugar Magnolia, the T. W. Latham home located at 804 Edgewood Avenue, has been splendidly renovated, including its three-story turret, grand staircase, and six fireplaces. Heartfield Manor, built in 1903 at 182 Elizabeth Street, surprises with a two-story entrance hall, including magnificent stained glass and original woodwork. Lastly the Woodruff Cottage at 100 Waverly Way opens its doors, inviting guests to see inside the house once belonging to Atlanta philanthropist Robert W. Woodruff. Welcoming visitors to Inman Park, these houses now serve as perfect examples of Inman Park's metamorphosis. (Sharon and Craig Jones.)

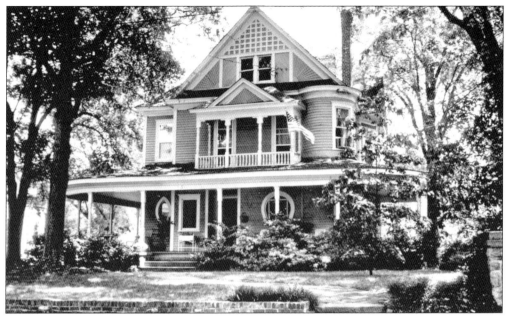

The house at 185 Elizabeth Street, originally the widow O'Keefe home, has been beautifully renovated and even featured in the magazine *Southern Living*. Today multi-colored azaleas frame the grounds, and the generous porch welcomes with true Southern charm. With 12 rooms and 9 fireplaces, this Queen Anne beauty is an Inman Park classic. (IPNA Archives.)

The lock-up box located in Delta Park on Edgewood Avenue was placed in its original location in April 1974 after being discovered in the dusty basement of the Atlanta Cyclorama. The Atlanta police had four lock-up boxes throughout the city from 1890 to 1905. These boxes were holding cells for criminals until the horse-drawn patrol wagons came on their regular rounds. (Sharon and Craig Jones.)

This photograph from around 1950 shows Springvale Park from the vantage of the Euclid Avenue overpass. Crystal Lake, a half-acre pond that Hurt kept stocked with fish, had been his jewel-in-the-crown. By the 1950s, it was merely an overgrown pond, filled with garbage and swarming with mosquitoes. No one objected when it was decided to drain the lake. (IPNA Archives.)

Springvale Park had become a dreary sight in the 1950s. Houses along Waverly Way were once privileged to lakefront views and the benefits of the fresh mineral springs. "At one end of the park is one of the finest chalybeate springs in the country. It gushes forth in a strong health-giving stream," exclaimed the *Atlanta Journal* on February 22, 1890. (IPNA Archives.)

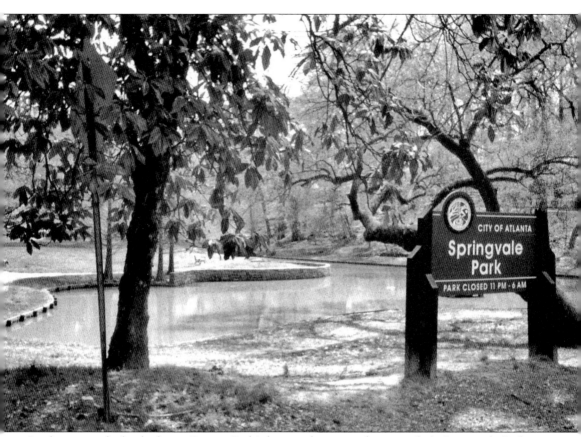

In the spirit of rebirth that is Inman Park's legacy, this image boasts today's Springvale Park with Crystal Lake as it was in Hurt's original designs. The restoration of Springvale Park is yet another tribute to the commitment of Inman Park residents' time, contributions, professional skills, and sweat equity. Thanks to funding from Inman Park Festival proceeds, federal funds, and matching grants from the National Trust for Historic Preservation and the State Historic Preservation Office, the community can look upon Springvale Park with pride. Residents aimed to recapture Hurt's ideal with authenticity, seeking out the original plant lists copied from the Olmsted brothers' drawings in 1903. With lush foliage all around, every season bursts anew with color. A playground was constructed in recent years, and the park remains a central gem for Inman Park residents. (Sharon and Craig Jones.)

Today residents of the Inman Park Historic District take great pride in their community, past and present. The welcome sign pictured here stands proudly on Edgewood Avenue to greet newcomers and residents alike. To the left of the welcome sign stands the lamppost generously donated to Inman Park by Rich's Department Store in 1973 to celebrate the restoration of the neighborhood. Inman Park is still the "Smalltown Downtown," and yet it is something much more. It is the bold story of Atlanta rising and a nationally recognized example of what sheer dedication on the part of simple citizens can do—for themselves, their homes, and their community. In this historic pocket of Atlanta, cherishing and preserving their heritage is a way of life. Inman Park has risen from its ashes and proudly represents the tradition of ingenuity, progressiveness, and diligence sustained by Atlantans today. (IPNA Archives.)

INDEX

Across America, People are Discovering Something Wonderful. *Their Heritage.*

Arcadia Publishing is the leading local history publisher in the United States. With more than 4,000 titles in print and hundreds of new titles released every year, Arcadia has extensive specialized experience chronicling the history of communities and celebrating America's hidden stories, bringing to life the people, places, and events from the past. To discover the history of other communities across the nation, please visit:

www.arcadiapublishing.com

Customized search tools allow you to find regional history books about the town where you grew up, the cities where your friends and family live, the town where your parents met, or even that retirement spot you've been dreaming about.